D0906200

HIDDEN
HISTORY
of
AIKEN
COUNTY

HIDDEN
HISTORY
of
AIKEN
COUNTY

Tom Mack

THE
History
PRESS

Published by The History Press
Charleston, SC 29403
www.historypress.net

Copyright © 2012 by Tom Mack
All rights reserved

Cover: Oil painting of Aiken County Courthouse with Confederate Monument. *Michael Budd, B.F.A.*

First published 2012

ISBN 978.1.54020.729.6

Library of Congress CIP data applied for.

CONTENTS

Acknowledgments 7

Introduction 9

1. 1540: Hernando de Soto Crosses the River 11
2. 1663–1783: Triple Betrayal Marks Native American Residency
 During Colonial Period 15
3. 1821: From Rags to Riches to Rags: Henry Shultz Follows a Dream 19
4. 1833: The Railroad Comes to Town 22
5. 1836: Most Edgefield Pottery Was Made in What is Now
 Aiken County 26
6. 1843: Sex Scandal Rocks the State's Power Elite 29
7. 1845: William Gregg Builds a Factory of Granite 33
8. 1846: Aikenite Invents Plastic Cotton 37
9. 1853: County Offers Sanctuary to Nineteenth-Century Botanist 42
10. 1865: Two Principal Adversaries at the Battle of Aiken
 Were "Frenemies" 47
11. 1865: Civil War Memoirist Calls Aiken His Home 51
12. 1868: Quaker Spinster Becomes Important Civil Rights Advocate 55
13. 1870: Croft Leaves His Stamp on His Adopted Community 61

CONTENTS

14. 1876: Graniteville Murder Remains Subject of Abiding
 Controversy 67
15. 1876: Massacre and Riots Mark Reconstruction Politics in
 Aiken County 71
16. 1887: The "Aiken Gamecock" Points the Way to the State's
 Constitutional Convention 75
17. 1900: Aiken Launches Career of Nation's "Assistant President" 80
18. 1906: James U. Jackson Revisits the Dream of a Town on
 the River 83
19. 1910: Aiken Mansion Boasts Two Significant Literary Links 87
20. 1912: Aiken Has Ties to *Titanic* Tragedy 92
21. 1918: Aiken Retains Tangible Links to Presidential Love Triangle 96
22. 1932: "The Black Caruso" Gets His Start at Palmetto Park
 and Pond 100
23. 1933: Fred Astaire Makes Aiken His Winter Home 103
24. 1936: Abdicated King Finds Solace in Aiken 106
25. 1943–46: German P.O.W. Camp Bears Witness to Daring
 Escape and Brutal Murder 109
26. 1951: Aiken County Revives the Political Ambitions of Strom
 Thurmond 112
27. 1952: Residents of Ellenton Become H-Bomb's First Victims 116
28. 1989: Joye to Juilliard: A Grand Aiken Home Has a Second (and
 Third) Life 120

Bibliography 123
About the Author 127

ACKNOWLEDGMENTS

In putting together this volume, I have enjoyed the helpful and timely assistance of a number of talented individuals:

•Deborah Tritt, instruction/reference librarian; Court Duvall, digital archives assistant, Gregg-Graniteville Library, University of South Carolina–Aiken.

•Elliott Levy, executive director; Mary White, assistant director; Brenda Baratto, collections manager, Aiken County Historical Museum.

•Janet Robinson, reference supervisor, Aiken County Public Library.

•Henry Fulmer, curator of manuscripts; Lorrey McClure and Beth Bilderback, South Caroliniana Library, University of South Carolina Columbia.

•George Wingard, Savannah River Archaeological Research Program.

•Carol McKay, College of Humanities and Social Sciences, USC–Aiken.

•Tayler Rodgers, Magellan Scholar, USC–Aiken.

Introduction

Although Aiken County was not officially established until 1871, I chose to begin this volume with 1540, the year of the earliest European engagement with this part of what would become South Carolina.

The present-day county, it can be argued, has been shaped by three transformative events. First, the establishment of the railroad from Charleston to Hamburg made it possible for inhabitants of the Lowcountry to enjoy the county's presumably more salubrious environment. "The recuperative qualities of its dry, pure atmosphere have been tried and tested by thousands of invalids," a nineteenth-century promotional brochure asserts. In addition, the "lofty evergreen trees" not only offer shade but also infuse the air with the "delicious balsamic odor exhaled from their leaves and trunks." It is, the same brochure proclaims, the "exhalations of these trees that soothe and purify mucous membranes of respiratory passages." Whatever the dubious validity of this claim, the advertising worked; by 1869, Aiken's hostelries could not accommodate even half the visitors seeking a room in what was then touted as a major health resort.

From an oasis for ailing members of the Southern planter class, the county next became by the end of the nineteenth century a center for the sporting activities of wealthy Northern capitalists. Great hotels were built first in Aiken and then North Augusta, and both towns flourished for a time as winter resorts.

Those glory days were on the wane when the federal government announced the construction of a nuclear reservation, which ushered in a third era of prosperity by attracting thousands upon thousands of new residents to the county in the 1950s and thereafter.

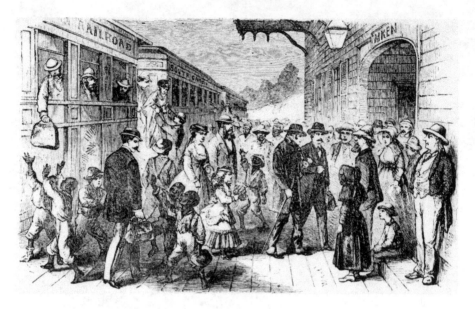

Arrival of the train from the North. *Aiken County Public Library.*

This book touches upon those three key developments in Aiken County history along with many others. Its aim, however, is not to present a continuous panorama of the past but to provide what might be termed snapshots of notable personalities and events. In fact, each of the chapters in this volume can be read as an independent narrative. Taken together, however, they make up a "hidden history" of this part of the state.

What is meant by the term "hidden"? In essence, each of these chapters can be placed into one of two categories:

- stories told for the first time in the pages of this book;
- stories retold through the lens of modern scholarship.

In the first category are chapters such as those devoted to largely forgotten individuals like the Civil War diarist Arthur Ford, political insider George Croft and the African American singing sensation Arthur Lee Simpkins; in the latter category are chapters such as those devoted to the Battle of Aiken or the role that Aiken County played in the political careers of John Gary Evans and Strom Thurmond, tales whose basic outline may be familiar to many readers but whose retelling, informed by additional research, takes on new meaning in the pages of this book.

Readers of *Circling the Savannah: Cultural Landmarks of the Central Savannah River Area*, my first book published by The History Press, may want to consult their copies of that volume for additional information about some of the individuals, events and places covered in this history.

Chapter 1

1540: HERNANDO DE SOTO CROSSES THE RIVER

In the sixteenth century, Europe was intensely interested in what would eventually become the Carolinas; the Spanish landed on the coast in 1521; the French established a fort on what is now Parris Island in 1562; and the English made an unsuccessful attempt to plant a colony on Roanoke Island in North Carolina in the 1580s.

During that same century, Europeans first set foot in what would become Aiken County. In fact, most historians agree on the date. On April 17, 1540, a Spanish expeditionary force led by Hernando de Soto crossed the Savannah River just below Augusta and entered South Carolina at a spot in what is now the Savannah River Site.

According to historical accounts, "the current was very strong...and the foot soldiers made a string of thirty or forty men tied to one another, and thus they crossed, the ones holding themselves to the others; and although some were in great danger, thanks to God, not one drowned, because they [cavalry] aided them with the horses, and gave them the butt of their lance or the tail of their horse."

A year earlier, De Soto had landed on the Gulf coast of Florida with over 620 men, and from that location, the group eventually decided to venture northeast because they had heard stories of the mining of gold "toward the sun's rising." On the way, De Soto, described as short in stature and "hard and dry as wood," adopted a course of action that the Spanish had already followed in their interaction with the native population in other parts of the Americas: he made false promises, took hostages and enslaved as many local inhabitants as he found useful.

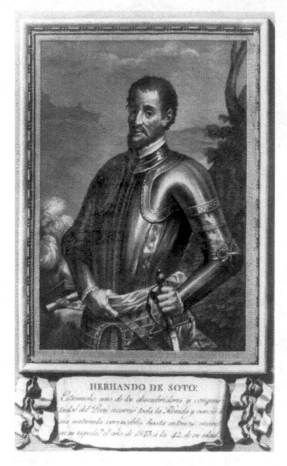

HERHANDO DE SOTO:

Hernando de Soto. *Library of Congress.*

Foremost among these was a Native American teenager named Perico, later baptized Pedro, who was used as a guide because of his knowledge of many indigenous languages. The Spaniards were also intrigued by Perico's tale of a place called Cofitachequi, ruled by a woman who collected tribute from neighboring Indian provinces. The word picture that Perico painted of a "wonderful" civilization built by a people possessed of gold, silver and pearls proved to be irresistible.

Because of the lure of great wealth, De Soto followed Perico's counsel as he led his expeditionary force from what is now the panhandle of Florida to what is now the Midlands of South Carolina. His faith in Perico did not waver until after he crossed the Savannah River and entered a swampy terrain whose topography delayed his progress; Perico had promised that from the river to the heart of Cofitachequi was only a four-day journey, but De Soto's men found themselves wandering in difficult terrain for nine days, often in heavy rain.

The Spaniards eventually stumbled on a Native American enclave near what is now Orangeburg, and the five thousand pounds of corn that they found there saved them from starvation. From thence, De Soto's force traveled north to a large town—the royal seat of government, whose location is still a matter of debate. Some historians believe it was located at the junction of the Saluda and Congaree Rivers near present-day Columbia; others think that it may have been either Lugoff or Camden on the Wateree River. To date, no archaeological evidence has been found to support either claim.

All accounts of the expedition, however, make one thing clear. The rulers of Cofitachequi had at one time controlled all the land from the Carolina coast to the mountains, and the present royal authority rested in the hands of a young woman, sometimes referred to as the Lady of Cofitachequi. De Soto's usual modus operandi in dealing with the native peoples he encountered involved first gaining control over their leader and then using that individual as a mouthpiece, demanding lodging and provisions as the Spanish army passed through that particular province.

The Lady of Cofitachequi turned the tables on De Soto since it was she that took the initiative in greeting the Spanish army, approaching De Soto's forces at first in a "canoe with an awning at the stern"—a mode of transportation that reminded one early commentator of Cleopatra and her barge.

This young queen presented De Soto strings of pearls and offered his men the hospitality of her province. Historians theorize that her welcome may have been prompted by the fact that her people had recently been decimated by a plague and that she sought to bolster her defenses against neighboring enemies by making an alliance with the strangers.

The Spanish stayed about eleven days in Cofitachequi, whose principal town featured a "very authoritative temple on a high mound." De Soto was, however, not at all interested in sightseeing. Indeed, although some of the Spaniards felt that the land was worthy of settlement, De Soto himself was intent on finding a treasure comparable to what Francisco Pizarro had discovered in Peru upon the conquest of the Inca. De Soto himself had been one of Pizarro's most effective captains, and he had grown wealthy from his share of the plunder, so rich that he had bought a palace in Seville.

No native gold or silver was found in Cofitachequi, but De Soto did examine temples and grave sites in the area from which he eventually extracted almost two hundred pounds of pearls—some presumably "as large as hazelnuts," which had been buried with the dead.

Accordingly, it was not long before De Soto set off for the Appalachian Mountains in his illusive quest for fortune, taking the queen of Cofitachequi hostage, much as Pizarro had done with Atahualpa, the Incan emperor. For about a month, he scoured the Blue Ridge valleys, and during that period, the captive queen is said to have escaped with some of her retainers. Her ultimate fate is unknown.

De Soto's demise, however, has been carefully recorded. He never again returned to South Carolina. Instead, his men traveled west through Tennessee, Northern Georgia, Alabama and Mississippi. He crossed the Mississippi River, but after exploring parts of modern-day Texas and

Arkansas, De Soto suddenly died of a fever at the age of forty-two. Fearing a Native American uprising should their leader's demise become public, his men deposited De Soto's body in a dugout canoe, which they sank in the great river.

For three years, De Soto explored the Southeast, but he found neither the treasure that he desired nor a suitable spot for colonization. Nevertheless, the written accounts of his expedition are just about the only record that we have of the Native American peoples that he encountered. According to many estimates, De Soto may have been both the first and the last European to confront the remnants of the mound-building peoples that we refer to as Mississippian; the Etowah and Ocmulgee sites that De Soto visited in Georgia are good examples of late-Mississippian settlements. In his wake, because of the diseases carried by members of his expeditionary force, including measles, smallpox and chickenpox, whole regions of the Southeast—what De Soto called La Florida—became depopulated. Sometimes discovery, no matter how it might ignite the human imagination, comes with a heavy price tag.

As an interesting footnote to this fascinating tale, it should be noted that most earlier histories of Aiken County adopt the theory espoused by John Swanton in his "Final Report of the United States De Soto Expedition Commission," published in 1939. In that document, Swanton claimed that the heart of Cofitachequi was in Aiken County, opposite Augusta. Controversy has always accompanied any effort to trace De Soto's four-thousand-mile journey through the Southeast, largely because today we have only rivers and vanished villages as landmarks and only one spot along the route has been archaeologically verified—the winter camp of 1539–40 in what is now downtown Tallahassee. Since Swanton's time, however, the scholarly consensus has shifted, and the Midlands are now regarded as the likely spot where De Soto met the ruler of Cofitachequi.

Still, there is no contesting the fact that De Soto crossed the Savannah River and traversed what is now Aiken County on his fabled journey and that this area remains part and parcel of his legend.

1663–1783: TRIPLE BETRAYAL MARKS NATIVE AMERICAN RESIDENCY DURING COLONIAL PERIOD

Not long after the founding of the colony in 1663, the Carolina proprietors licensed traders to negotiate with the Native American population in the backcountry for processed furs, then in much demand in Europe. So profitable became the trade that from 1699 to 1715, fifty-four thousand skins were procured each year; this figure tripled by the middle of the eighteenth century.

How did the trade affect Native Americans? At first they thought that they were getting a bargain, exchanging what they often perceived as used clothing for exotic European goods. However, the hunting that had once been undertaken largely for subsistence gradually became a commercial enterprise, and the lifestyle of Native Americans became increasingly dependent on their relationship with these backcountry traders.

Despite government attempts to control their conduct, this latter group had a great deal of individual discretion. In 1707, for example, South Carolina passed an act to create a Board of Indian Commissioners to regulate traders, particularly regarding the sale of guns, ammunition and liquor. The board did some good. A South Carolina trader named Charlesworth Glover, for example, notified the board in 1717 that the local Savanna tribe had complained that they paid more for European goods than their Native American neighbors. As a result of Glover's intervention, the board authorized a price rollback.

Still, some of the most powerful traders acted as a law unto themselves; this might be, in part, because they were mostly of Irish or Scottish heritage and had a general antipathy toward taking orders from the English. This

independence of spirit was certainly a characteristic of George Galphin, who emigrated from Ireland in 1745 and eventually settled on a parcel of land he called Silver Bluff because of the long-held belief that it was there that De Soto had set up camp in his quest for treasure. Galphin had been employed by the government initially as an interpreter—backcountry traders at this time often took Indian mates in order to learn native languages, and Galphin's career follows this pattern. In fact, some historians estimate that he may have had as many as a half dozen "wives" in disparate locations: one back in Ireland, one on his Silver Bluff property and several among the native population.

Galphin eventually became a partner in the influential Augusta-based firm of Brown, Rea and Company, which controlled three-fourths of the Indian trade in the Central Savannah River Area by 1755. He was so powerful that despite claims that he inflated the bills for European trade goods—the items exchanged for processed furs—and that he engaged in the illegal trafficking of guns and rum, there was relatively little that the government could do.

The famous naturalist William Bartram enjoyed Galphin's hospitality at his Silver Bluff plantation in the spring of 1776, and he noted in his journal that Galphin was a "gentleman of distinguished talents, who possessed the most extensive trade, connections, and influence among the Indian tribes." Galphin eventually became a reluctant Patriot, convinced that the British were inciting Indian attacks on European settlers as part of their Southern campaign.

During the colonial period, roughly from 1663 when a charter was granted to the original Lords Proprietors to the end of the American Revolution, there were three successive Native American residencies in what would eventually become Aiken County. The first were the Westos, who emigrated from Virginia around 1670. Armed with guns that they had acquired from Virginia traders, the Westos terrorized the original people of the Savannah River Valley by making frequent slave raids on other tribes. The earliest European account of Native American affairs in this area comes from a visitor to Westo territory, Dr. Henry Woodward, who was himself a colorful figure in our state's early history.

Of Scottish heritage, Woodward had once been a surgeon on English privateer vessels until he decided to make contact with coastal Indians around 1666. After escaping imprisonment by the Spanish, he is credited with establishing in 1669 the trading system between the English and the indigenous people of South Carolina.

In pursuit of this enterprise, Henry Woodward gladly let the Westos escort him to one of their villages on the Savannah River in 1674. He described their principal residences as long houses covered on the top and sides with

bark and decorated with the scalps of their enemies hung on poles. During the ten days that he stayed in the village, Woodward noted their defensive palisade—double on the landward side and single on the riverside—and nearly one hundred canoes resting on the riverbank.

The Westos conducted trade with the South Carolina colonists with relatively little incident for five years until hostilities broke out in 1679. By the next year, the tribe had been wiped out with everyone killed or enslaved—most captured Native Americans at that time were sent to the West Indies to work on sugar plantations. Thus, ironically enough, the tribe that had first profited from the slave trade were themselves ultimately the victim of that very same practice.

The Westos were replaced in this area by the Savanna Indians, whom some historians now believe were a branch of the Shawnee Nation that migrated to the Savannah River Valley in the late seventeenth century. The Savanna assisted the South Carolina government in their war against the Westos, and as compensation for their efforts, they eventually inherited Westo land.

This was a principal feature of general colonial policy aimed at subjugating the native population by means of exploiting traditional tribal rivalries. During the time of the Savanna residency, Fort Moore was constructed on the South Carolina side of the river on a high bluff, which William Bartram later claimed rose one hundred feet above the river about six miles below Augusta.

The fort, built by local militia around 1715–16 and named after former governor James Moore, was greatly enhanced in 1747 with ten-foot walls, a walking platform across the top and an array of cannons. The garrison was never very large most of the time—averaging somewhere between ten and twenty-five men, but it was frequently augmented during periods of conflict.

Eventually the Savannas abandoned this area, joining northern elements of their tribe, because it is claimed that the English officials grew to favor the Catawba as their principal Native American allies in the colony. The Catawba were traditional enemies of the Shawnee.

The third and final Native American residents to settle in this area were the Eastern band of the Chickasaw Nation, whose members were lured to this side of the Savannah River by the South Carolina government in 1723.

The most colorful figure of the sixty-year period of Chickasaw residency was Squirrel King, who aroused the interest of quite a few early commentators. John Tobler, a local Swiss settler, described in his journal his first meeting with Squirrel King, whom he said was "painted strangely with red color" and wearing a "beautiful brass breastplate." Indian agent Edmund

Atkin reported that he had the reputation of having "killed more men by his own hands than any other Indian on the continent." According to some accounts, he was the undisputed leader of one of two bands of Chickasaw in the Central Savannah River Area; his particular group included at least seventy warriors and their families, all residents in the Horse Creek Valley.

Squirrel King was certainly an individual of some presence and one who was more than willing to assert his authority when he felt justified. In 1747, for example, he led a delegation of his people to Charleston to protest the fact that European settlers were stealing horses and disturbing cornfields; the Royal Council took his side in the dispute, providing the Chickasaw with compensation for their losses.

Just as the Westos and the Savannas before them, the Chickasaws were used as a buffer between the British and the other colonial aspirants in this region of the country: the Spanish and then the French. All three European powers used Native American allies to advance their territorial schemes, banking on traditional tribal rivalries to stoke the fire. Historian Robert Meriwether asserted that the Chickasaw were the "boldest of the Southern tribes," and there is plenty of evidence that they were frequent and fierce combatants. In 1742, for example, they were part of an English force that repelled a Spanish attack against Fort Frederica on St. Simon's Island, Georgia. In 1752, the local Chickasaw fought an invading band of Cherokee; and in 1754, they fought off marauding Mohawks. Both of the latter intruders had entered what would become Aiken County at the behest of the French.

As an interesting side note, one can mention that some of our modern-day understanding of the importance of hunting in Native American culture comes from early European accounts of how the Chickasaw viewed the symbolic importance of various pelts. In infancy, females were often wrapped in deer or bison skins while males were wrapped in panther hides so that each sex could, through a kind of spiritual osmosis, receive the dominant attributes of each animal—the females raised to be more docile, the males to be more aggressive.

The Chickasaw eventually lost their land grant in 1783, when everything they owned was confiscated by the new American government following the Revolution. Like many Native American tribes, the Chickasaw had sided with the British during that conflict, putting their trust in the Royal Proclamation of 1763, which prohibited European settlement west of the Appalachian divide.

All in all, by the middle of the eighteenth century, the Indian trade no longer dominated the commercial life of the Central Savannah River Area. Land speculation and settlement became the order of the day, and thus begins our next chapter.

1821: FROM RAGS TO RICHES TO RAGS

Henry Shultz Follows a Dream

A poor German immigrant who arrived in the Central Savannah River Area in 1806, Henry Shultz rose by virtue of his imagination and hard work from a position of relative obscurity to become one of the most important entrepreneurs in South Carolina. In essence, he led a one-man campaign to break the dominance of Augusta as a trading center in the upper reaches of the Savannah River Valley.

For seven years, Shultz worked on the river transporting cargo between Augusta and Savannah, first as a humble boatman and then as the owner and captain of his own tobacco flatboat christened the *Diana*. In 1813, he and a local partner conceived the notion of building a toll bridge across the river linking the planters and farmers of western South Carolina to the merchants of Augusta. From its opening in 1814, the bridge paid dividends. It also set the pattern for many of Shultz's schemes to follow.

His is a tale of overreaching ambition. Not content with the success of the bridge, Shultz next set his sights on establishing a bank, called the Bridge Bank, as well as a new wharf in Augusta and a steamboat company. By 1819, he lost both the bridge and the bank. Some historians claim that he sold his interest in both enterprises when he realized that he had overextended himself; others assert that he was swindled by unscrupulous Augusta businessmen and that in his despair over the failure of both enterprises, he attempted suicide. Under new management, the toll bridge stood until 1888; the bank failed shortly after Shultz's tenure, largely due to the mishandling of his former partners, John and Barna

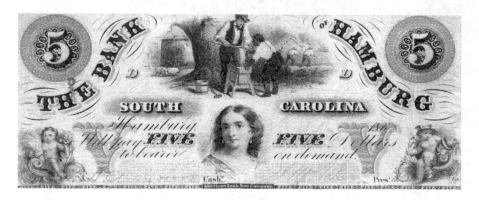

Five-dollar bill issued by the Bank of Hamburg. *Collection of the author.*

McKinne, two Augusta brothers who had used the bank to fund their other mercantile interests.

Whoever was to blame for the loss of his bank and bridge, Henry Shultz was always thinking up new business ventures. He soon set his sights on a South Carolina cornfield on a river bluff opposite Augusta. Eventually he took out a six-year lease on 330 acres and set about establishing a town, which he named Hamburg after his German birthplace. One year after its founding in 1821, Hamburg boasted eighty-four houses and two hundred people.

Shultz was the town's biggest and most successful booster. In an advertisement from that period, he wrote, "As Hamburg will attract the attention of the citizens of South Carolina, North Carolina, and Tennessee, and nature having done much for it; if assisted by art, the undersigned has not the smallest doubt it will become a place of great importance."

The natural advantages of the site, according to Schultz, involved both the configuration and depth of the river and the elevated topography. First of all, for a mile opposite Augusta, the Savannah River ran deeper on the Carolina side so it proved to be a more attractive docking point for steamboats.

The placement of Hamburg on a bluff sixty feet above the river was also touted as more salubrious than the low-lying situation of Augusta, whose principal acreage had been salvaged from swampland. Furthermore, it was conceived that the smoke from Augusta would protect the new town from "miasmata." A commonly held belief of the time was that certain diseases were caused by the poisonous atmosphere or "bad air" associated with environments replete with stagnant or undrained water.

Shultz's success as a salesman can be measured by the fact that the state legislature approved a loan of $50,000 in response to his plea for additional

funds to complete the construction of the town and purchase a steamboat. The latter vessel, christened *Commerce*, began plying the waters between Hamburg and Charleston in 1822, and trade between the two points soon prospered.

It was not long, however, before the leading merchants of Augusta struck back, by removing tolls for bridge traffic going into the city but not in the other direction toward Hamburg and by figuring out ways to reduce shipping charges from their docks to and from Savannah. According to a number of sources, South Carolina cotton was prized over its Georgia counterpart because the latter was thought often to be full of rocks—thus, the bale would weigh more and the buyer got less cotton per pound—and inferior cotton was often hidden in the interior of each bale. Thus, securing the sale of superior South Carolina cotton on the Georgia side of the river was a considerable coup.

For a variety of reasons, trade slowly shifted back to the Augusta–Savannah river route, and Charleston merchants, who had backed Shultz's initial scheme involving river commerce, turned their attention in 1833 to the construction of a railroad between that city and Hamburg.

Rather than save the town, the railroad ironically became the major player in its demise. In 1852, a trestle was constructed across the river to Augusta, and Hamburg ceased to be the terminus of the first railroad in South Carolina. By the time of the War Between the States a few years later, the town was nearly deserted.

Long before that point, however, Henry Shultz had problems of his own. The first involved homicide. He was implicated in the death of a man whom he and two others were interrogating in order to get information on the whereabouts of a stolen trunk; the suspect later died from the beating, and Shultz and one of his accomplices were convicted of manslaughter. A timely pardon from the governor spared them a six-month prison sentence and the branding of the letter "M" on the left thumb.

Hard on the heels of that first trial was a second court case. This one involved a lawsuit over outstanding debts; Shultz was spared from prosecution by assigning all of his property to a group of trustees. He died in the autumn of 1851, a poor man. According to local legend, he is buried on Shultz Hill from whose crest motorists on Route 1 can see spread out before them Augusta, the city on the other side of the river that had the last word in this remarkable tale of rags to riches to rags.

1833: The Railroad Comes to Town

Commenting on the key role that the railroad continues to play in our nation's history, President John F. Kennedy made the following statement in October 1960: "It was the railroads that linked together the diverse segments of this vast land so that together they might become the greatest economy the world has ever known."

Certainly his assertion rings true for Aiken's storied past because the railroad was not only responsible for the founding of the town but also for its continued prosperity as a health resort and sporting mecca.

Aiken was developed as a stop on the South Carolina Railroad, the brainchild of a group of Charleston entrepreneurs determined to connect their city to the state's interior and thus ensure Charleston's preeminence as the "commercial emporium of the South."

Alexander Black secured a state charter for the SC Railroad and Canal Company in 1827 and chaired the committee that explored the relative merits of building a railroad or building a canal. The railroad option proved the more attractive, and a subscription of stock was authorized in 1828.

That was also the year that William Aiken became president of the company, a position that he held for three years until his death in the spring of 1831. During his tenure in that position, most of the construction of the new line, which eventually covered 136 miles from Charleston to Hamburg along a ridge roughly parallel to the course of the Edisto River, was completed. Most of the land along the route was gifted to the company. Much of the backbreaking work to lay the tracks was accomplished by slave

labor; individuals were hired out by their owners residing at various points along the route.

Despite these advantages—free land rights and cheap labor—financing was a continual problem. This deficiency in private capital led Black and Aiken to travel to Washington, D.C., in 1829 to petition the federal government for aid. Theirs was a delicate mission since no state politician at that point in South Carolina history would publically seek aid from the national government because such a request was viewed as undercutting the principle of state sovereignty. State politicians would rather refuse federal aid than admit any federal control over state affairs.

Bypassing South Carolina's representatives in Congress, Aiken wrote directly to Daniel Webster, senator from Massachusetts and a leading opponent of nullification, asking him to introduce a bill in support of the railroad largely on the grounds of its usefulness in time of war. According to Aiken, one thousand troops and related military stores could be transported by rail one hundred miles in less than twelve hours. Webster did as requested, but the bill died in committee.

Needless to say, William Aiken's attempt was not viewed with approbation in his home state. Still, his petition to the federal government may have played a part in loosening up the state's purse strings because the legislature granted a loan to the company later that same year. Considering his political leanings, it is not surprising that Aiken looked for Washington for help; during his short stint in the state legislature, there were two dominant factions: Unionist and States Rights. Aiken was a Unionist.

Aiken also oversaw the first trial run of a steam locomotive on the six miles of track completed by Christmas 1830. On that date, the steam locomotive Best Friend hauled 141 passengers at speeds ranging from fifteen to twenty-five miles per hour and, according to one observer, "annihilating time and space, leaving all the world behind."

As fate would have it, William Aiken did not live long enough to learn of the demise of the *Best Friend*, whose boiler burst in June 1831 due to the presumed negligence of a fireman who accidentally closed the safety valve so that no steam could escape. Aiken died a month earlier when he was thrown from his carriage, an accident that occurred, as the legend goes, when a train whistle frightened his horse.

Whatever the facts may be about his fatal injury, William Aiken played a major role in one of South Carolina's greatest technological achievements. The railroad literally transformed the face of the state. Towns sprang up at points where the railroad built depots and other specialized facilities like

water towers—early locomotives ran on a combination of pressurized water and steam. Some, like Branchville, have names that directly indicate their relationship to rail travel—the town may have served as the world's very first railroad junction when a second "branch" was established to Columbia in 1842. Other towns, like Aiken and Blackville, were named for some of the railroad's principal planners.

Downtown Aiken still conforms to the grid pattern dating from 1834 when two railroad surveyors, Alfred Dexter and Cyril Pascalis, laid out the city's original twenty-seven rectangular blocks interfaced with wide streets divided by parkways. In its early days, the railroad owned much of the property in town. It operated its own hotel and sometimes donated lots for civic causes, granting one lot for a school and apportioning a half lot to a local Baptist congregation.

By 1835, one could cross the state by rail. According to an advertisement that year in *Miller's Planters and Merchants Almanac*, passengers could travel from Charleston to Aiken in less than ten hours for a six-dollar ticket, departing at 6:00 a.m. and arriving at 3:45 p.m. The speed varied according to the length of the train; locomotives pulling one car could travel at fifteen miles

Reconstructed Aiken train depot. *Tom Mack.*

per hour; pulling two cars, at twelve miles per hour; and pulling three, at ten miles per hour. Each car held approximately twenty-five passengers.

The original company, however, survived less than twenty years, merging with the Louisville, Cincinnati and Charlotte Railroad in 1844, becoming the South Carolina Railroad Company. It was in its new incarnation that it suffered its greatest setback when in February 1865, Union forces under General William T. Sherman invaded the state. "This is an important railroad," Sherman asserted, "and I plan to destroy it completely for fifty miles." He was a man of his word for his army thoroughly tore up the rails between Aiken and the Edisto River, a distance of forty-nine miles. To meet his goal, he employed a practice already made famous during his march to the sea; this is the creation of Sherman's "neckties," rails heated in the middle over bonfires and then bent around tree trunks until they resembled men's neckwear.

In addition to the stretch already mentioned, Sherman destroyed the Orangeburg depot and demolished all of the railroad property in Columbia: bridges, trestles, depots and water tanks. Even before Sherman's all-out assault on the railroad, however, its future was less than sunny. The company had never run a profit, and it was eventually bought by New York capitalists in 1878.

1836: Most Edgefield Pottery Was Made in What is Now Aiken County

What we know today as Edgefield pottery, utilitarian stoneware with a distinctive alkaline glaze, derives its name from the Old Edgefield District, not from the town or county of Edgefield. In fact, most of the Edgefield pottery produced in the nineteenth century was actually made in what is now Aiken County in a number of manufactories on the banks of Horse Creek or Shaw's Creek. Edgefield County can still claim bragging rights as the birthplace of the pottery tradition, but it is modern-day Aiken County where most of what we now know as Edgefield pottery was made.

The story begins with Dr. Abner Landrum, who was something of a Renaissance man in this part of the state. A physician and newspaper publisher of Scotch-Irish descent, Landrum is credited with having unlocked the secrets of an ancient Chinese stoneware formula and having rediscovered the science of building a kiln massive enough to fire large quantities of pottery at the same time.

In 2011, an archaeological team from the University of Illinois at Urbana–Champaign excavated the site of the original kiln. What the researchers and students found was totally unexpected. Digging back from the front wall of the kiln, they uncovered a structure 105 feet in length, at least 90 feet of which—an estimated 5,000 cubic feet in all—was devoted to the chamber to house the unfired pottery.

Undoubtedly the Landrum operation in what was at first called Landrumsville and then Pottersville, about a mile and a half east of the courthouse square in Edgefield, was a major enterprise, much bigger and

much more sophisticated than had been previously theorized. The kiln itself resembles the "anagama" or cave kiln whose design Japanese potters imported from China in the fifth century. It is a single-chamber kiln built into the side of a slope, with space for the fire near the entrance and the flue on the other end. Such an up-draft kiln would have required round-the-clock stoking for a period perhaps of days, and such an operation—including digging the red clay and kaolin, working the pots, preparing the glaze mixtures, chopping the wood for fuel and loading and unloading the kiln—took a lot of manpower. Landrum and his fellow pottery producers initially used enslaved labor for most of the unskilled work; the original "throwers" were essentially itinerant white potters. However, due to the instability of this particular labor force—most of these craftspeople were often lured away by better prospects in other parts of the country—the Edgefield employers eventually trained enslaved workers to take on the more creative tasks.

In this regard, there is no more famous African American potter than David Drake, whose large-scale vessels, often inscribed with his name or some fragment of verse, have become the subject of considerable scholarly study and popular attention. Born in this country around 1801, Dave was most likely purchased at the age of fifteen by Landrum, who put him to work doing minor tasks related to the pottery until he was eventually trained to turn pots. Some believe that Harvey Drake may have been his teacher, especially since Dave took the surname Drake upon emancipation in 1865.

Drake, Landrum's son-in-law and his brother Reuben purchased Dave along with the Pottersville Manufactory in 1829 when Landrum decided that he needed to focus his energies on his newspaper. Dave's days in Pottersville were numbered, however, because by the latter part of the next decade, Dave was working in a pottery owned by the Reverend John Landrum, Abner's brother, at the headwaters of Horse Creek in what is now Aiken County.

This particular location near Vaucluse became the center of Edgefield pottery production. Dave's relocation to the Horse Creek Valley also ushered in his most creative period. Landrum's son-in-law Lewis Miles—80 percent of the pottery owners were related by blood—comes into the picture at this point; Dave worked for Miles on and off for the next thirty years, principally at the latter's Stony Bluff Manufactory, which employed nine workers in 1850 and produced wares worth an estimated $100,000 in today's prices.

Most of Dave's most notable pots were made during his time with Lewis Miles. These include two jars, both on view at the Charleston Museum, that have been called by art historians "the largest and most spectacular slave-made vessels known." Each holds forty gallons, and the taller of the

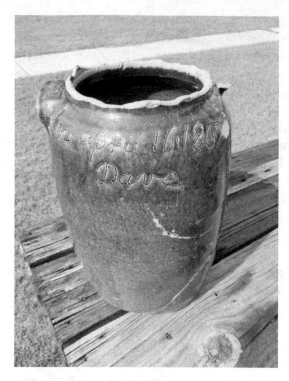

Unearthed food storage jar, David Drake, 1862. *Savannah River Archaeological Research Program.*

two measures almost twenty-nine inches in height; it is theorized that both were made by a combination of turning and coil construction—the bottoms turned on a wheel and the tops made by adding clay in concentric rings that were subsequently smoothed over.

In addition, of the twenty-nine authenticated vessels with Dave's mostly homemade verse, all but eight were made at Stony Bluff. Of the two biggest jars Dave ever made, one is inscribed with perhaps his most famous couplet: "Great and Noble Jar/hold Sheep goat or bear." The other reads, according to Leonard Todd, the author of the definitive biography on Dave: "made at Stony bluff, for making or adgin [ageing] enuff [enough]."

The date of David Drake's death is not known—it is now thought that he died at some point between 1873 and 1880. What is certain, however, is that he died a resident of Aiken County, which was formally established in 1871.

What happened to the stoneware pottery business in the Horse Creek Valley? With the proliferation of cheap glass and metalware, the popularity of utilitarian stoneware vessels declined so that, one by one, the potteries in Aiken County ceased operation in the last decades of the nineteenth and first decade of the twentieth century.

Chapter 6

1843: SEX SCANDAL ROCKS THE STATE'S POWER ELITE

In the mid-nineteenth century, there was no more prominent citizen in what was to become Aiken County than James Henry Hammond. Besides his status as the wealthiest landowner in this part of the state, he was also a political powerhouse, having served not only as our state's governor (1842–1844) but also a U.S. congressman (1835–1836) and senator (1857–1860).

Born in Newberry County in 1807, the son of an educated but ne'er-do-well father, Hammond was a man of vaunting ambition. His first taste of a life of privilege and power came from his undergraduate experience at South Carolina College, now the University of South Carolina, where he rubbed shoulders with the sons of the wealthy planter class.

He himself had no influential connections, so he decided to acquire them through marriage. Already attractive to the opposite sex because of his dark good looks and readiness of wit—he had excelled at oratory in college and, for a time, practiced law and edited a newspaper—Hammond fixed his gaze on the fifteen-year-old Catherine Fitzsimons, whom biographer Carol Bleser describes as "plain-looking, fatherless, shy, and awkward."

What the unprepossessing girl lacked in looks and manner, however, she more than made up for in property; she had inherited a number of plantations in the area of Beech Island. As might be expected when the charismatic but penniless Hammond came courting, her family objected to the presumptive match, but Hammond ultimately prevailed and carried off his bride two years later in 1831. It would take another year, however, and legal arbitration

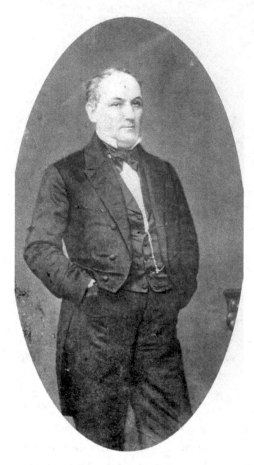

James Henry Hammond cabinet photo. *South Caroliniana Library, USC.*

before Catherine's older brother ceded control of her estate to her new husband.

Hammond soon set about improving his investment, by fathering eight children by Catherine—only five lived to maturity—and by making a concerted study of agricultural practices in order to expand his acreage under the plow.

Although Hammond always praised his wife in public—and sometimes in private—for what she brought to the marriage, Catherine herself was not always so sanguine. As was often the case among the planter class during this period, Hammond sought female companionship among his human property. In 1839, he purchased an eighteen-year-old mulatto female named Sally and made her his mistress; her one-year-old daughter Louisa, also part of the purchase agreement, he made his mistress when she turned twelve. As one might imagine, his long-suffering wife Catherine eventually had enough, and she took the children that they had together and left Silver Bluff Plantation to live on her own, first in a house in the Summerville section of Augusta but also in rental property in Aiken. This was in 1850, and she did not return to live with her husband until about five years later, when he built his showcase plantation Redcliffe, now a state historic site.

Curiously enough, this dramatic rift was predated by yet another breach of marital concord, an affair—or series of affairs—that one might have thought would have driven Catherine from the marriage bed more precipitately than his dalliance with his female slaves. This involved his self-confessed dalliance with four of his nieces through marriage.

For a two-year period, from 1841 to 1843, Hammond had weekly encounters with the four daughters of Wade Hampton II, who had married Catherine's sister. The girls ranged in age from thirteen to eighteen at the time, and according to Hammond, they all individually welcomed his advances. In fact, while acknowledging his conduct as reprehensible, he put part of the blame on the motherless girls themselves for initiating some of the activity—willingly rushing into his arms, sitting on his lap and apparently permitting his hands to stray unchecked in their "secret and sacred regions."

Hammond fully expected repercussions when the second-oldest daughter, named Catherine, by then nineteen years of age, rebuffed him for the first time in 1843. In fact, he was prepared to be called out by one of the Hampton males and to have to defend himself in a duel or to be waylaid and murdered in the street.

Instead, Wade Hampton II and his influential relatives chose to initiate an undercover campaign to blackball Hammond in their social circle. Their clandestine efforts, however, took a public turn when James Henry Hammond put his hat in the ring for a U.S. Senate seat in 1846 and again in 1850. Before the early twentieth century, senators were elected by their respective state legislatures, and the Hampton faction circulated among the members of the legislature reports that Hammond had tried to seduce one of his nieces by showing her indecent pictures.

The true story was, one might argue, far worse, but Hammond wrapped the mantle of indignant outrage upon his shoulders, accusing Wade Hampton II of being a "poltroon," from the Italian for "coward," for exposing his children to public disgrace. At least, Hammond—he congratulated himself— had the decency to keep quiet about the affair. If Hampton had sought quick redress of his grievance by challenging Hammond to a duel, the latter avowed that he would have "received his first shot without returning it." This delayed revenge, however, Hammond considered beneath the conduct of a gentleman.

Because of his self-proclaimed discretion and restraint, Hammond expected praise, not censure. He told his political allies that he had stopped short of intercourse. "Am I not entitled to some credit for not going further?" he opined. Given his personal predisposition—Hammond always made much ado about his "morbid and solitary habits"—he argued that he could not be fully blamed for taking advantage of his nieces' "loose manners" and "ardent temperaments." Was there anything fundamentally wrong, he mused, in being "keenly alive to every excitement of which [he] could partake"?

Despite his private efforts to defend himself by seeking out others who might take his part, Hammond lost his political bid that year, and he was left to retire from Columbia to what he considered an "obscure" part of the state to lick his wounds. Although he claimed to have "profound regret" for his "great indiscretion," Hammond continued to heap more blame on his Hampton relatives for making public a "private and most delicate family matter."

It was not until 1857 that Hammond was, surprisingly enough, able to resurrect his political career after a thirteen-year exile from the seats of power; that year, his election to the U.S. Senate was announced despite the fact that he had refused to campaign. Hammond, in his characteristically self-serving way, regarded the victory as a "signal triumph" over his enemies—the Hampton faction—and a fresh start. "It wipes off every calumny," he writes in his diary, "and puts my name among the foremost of South Carolina without a stain."

This has not necessarily been the judgment of posterity. Certainly if one considers the fate of the four young women in this narrative—none of them ever married—one must regard this unfortunate episode as one of the most lurid in a long line of sex scandals involving South Carolina politicians.

1845: WILLIAM GREGG BUILDS A FACTORY OF GRANITE

L ong before the period of economic transformation labeled the "New South," one particular South Carolinian hoped to convert his native region from an agricultural society to one whose prosperity was based on commerce and industry. That man was William Gregg.

Born in what is now West Virginia in 1800, Gregg apprenticed to a watchmaker and silversmith in Kentucky and then Virginia before setting up a business in Columbia, South Carolina, in 1824. By all accounts, he made up for a lack of formal education with a strong mechanical aptitude.

In 1829, he married Marina Jones of the Old Edgefield District, part of which later became Aiken County; and although he opened a shop in Charleston as a jeweler and silversmith in 1838, he never lost interest in the part of the state where his wife grew up. In fact, he bought a part interest in a cotton mill in the village of Vaucluse.

Because of that investment, William Gregg became a student of manufacturing processes. In 1844, he toured the textile mills of New England; and in 1845, he published a volume entitled *Essays on Domestic Industry*. Gregg was very concerned about what he saw as the state's overdependence on agriculture: "An exclusively agricultural people will always be poor. They want a home market. They want cities and towns, they want diversity of employment."

That same year, he established a corporation to raise $300,000 for the construction in the Horse Creek Valley of a mill for the "dyeing, printing, and finishing of all goods of which cotton and other fibrous articles form a part." The first meeting of subscribers was held in Aiken.

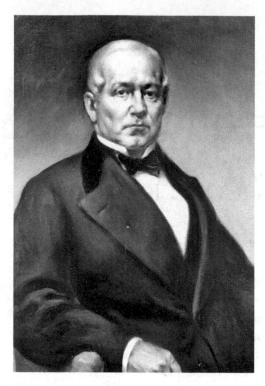

William Gregg. *Gregg-Graniteville Archives, Gregg-Graniteville Library, USC–Aiken.*

Even before the state granted the Graniteville Manufacturing Company its charter, Gregg had bought the land—11,000 acres—and began laying out the site. In the antique meaning of the word, he was a true "projector." He took a personal interest in every aspect of the project that he had launched. Gregg dammed the Big Horse Creek, dug a mile-long canal, built a main factory building of local blue granite and constructed a turbine water wheel. By 1848, in addition to the main building, two stories high with front towers featuring interior staircases, Graniteville boasted a sawmill, gristmill, two warehouses, workers' cottages, two churches, a schoolhouse, a hotel and assorted boardinghouses and stores.

An astute businessman, Gregg had his eye on the bottom line, but he also wanted to make a difference in the lives of poor whites, mostly tenant farmers, whom he characterized as "a noble race of people reduced to the condition but little above the wild Indian or the European gypsy." With the proper discipline and moral restraints, both of which he was ready to impose, he felt that they could improve their lot in life.

Thus, he implemented what he considered reasonable working hours—twelve-hour days from 7:00 in the morning to 7:30 at night with a forty-five-minute break for lunch. In addition to wages, the workers were given garden plots and hunting privileges in the surrounding woods. He provided a school and made education compulsory to age twelve; he encouraged church attendance, and he made medical attention available.

In 1854, Gregg moved his family to Kalmia Hill not far from his model village. From his estate, he could keep an eye on his employees and enforce his rules regarding school attendance and the prohibition of social dancing

and alcoholic consumption. He often dropped in at the school to count heads, and he was not averse to reprimanding villagers who were known to frequent local saloons. In an address to his stockholders in 1854, Gregg asserted that "control of the proprietors" was essential if one were to "keep up a steady, efficient, and cheap working force."

Control, no matter how philanthropic were its intentions, was the order of the day and, as far as Gregg was concerned, a necessary foundation for a successful manufacturing future. In fact, he envisioned uplifting generations of "miserable poor white people" by placing them "in a situation in which they would be educated and reared in industrious habits."

Given his didactic tendencies, it is not surprising that Gregg would eventually be attracted to the political arena. In 1856, he was elected to the state legislature, where he soon established a reputation for pragmatism. Indeed, even though he was personally opposed to secession, partially because he feared that the South would not have the industries to supply her needs in time of war, he felt compelled to join the planters and merchants who made up the convention that met in 1860 in Columbia at the First Baptist Church and the next day in Charleston. Against his better judgment, he signed the Ordinance of Secession.

When hostilities commenced, he did his best to keep up production in Graniteville despite the fact that the draft reduced his workforce by half. Union forces never invaded the village—thanks in part to the Confederate victory at the Battle of Aiken in February 1865—but the railroad was destroyed by Sherman's army, so Gregg devised a way to get his goods to Orangeburg by mule wagon.

The factory and the village were his main concern. In May, one month after Lee's surrender, he petitioned Brigadier General E.L. Molineux, the federal commander in nearby Augusta, for permission to keep the rifles and ammunition that his company already had on hand "until order was restored"—the reply authorized him to retain 50 of the 150 rifles in his arsenal. Not long thereafter, Gregg was in New England and Europe, buying new machinery and investigating the latest manufacturing methods. Although his son James was superintendent by that time, William Gregg never really retired. In fact, when a dam broke in 1867, he was there with the other men, waist deep in water, trying to repair the damage. The exertion was too much for him, and he died a week later, at the age of sixty-seven.

On the granite obelisk that marks his original resting place in Graniteville Cemetery—the body was exhumed and reburied in Charleston at a later

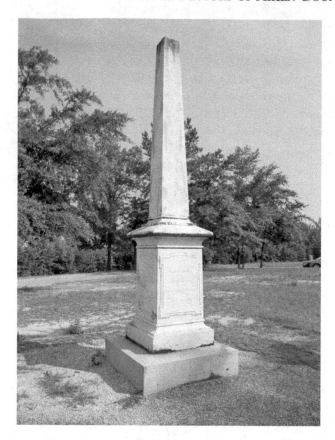

Gregg Memorial, Graniteville. *Tom Mack.*

date—are carved the following words: "The Devoted Husband, Father, Friend, and Benefactor to the Poor, He was by His Many Virtues Endeared to All Around Him." That is how Gregg saw himself, and that is how he would have wished to be remembered by others.

Chapter 8

1846: Aikenite Invents Plastic Cotton

A t the bottom of Laurens Street in Aiken, just above the railroad bridge, is a small cottage that is, according to some estimates, one of the first buildings erected in the town. In 1846, it became the residence of the Legare family—John D. Legare and his wife, Mary, and son James.

Young James Mathewes Legare suffered from tuberculosis, and the family had moved from Charleston to Aiken in part because of the latter's reputation as a health resort—even in its early days, Aiken was touted as a hamlet with a salubriously dry climate due to its elevation and distance from any large body of water—and in part because of what they hoped would be financial opportunity.

Despite his delicate health, James Legare hoped to add to the family income and coincidentally make a name for himself by trying his hand at a number of occupations. He was a teacher, a painter and a writer. In 1848, he published to good reviews a book of poems entitled *Orta-Undis*, from the Latin for "sprung from waves," a possible reference to the birth of Aphrodite. He also turned his creative energies to science by pursuing what he called "mechanical invention."

In a letter that he later wrote to James Henry Hammond, an important figure in state politics and perhaps the richest man in the district, Legare confessed to lofty ambitions in the mechanical arts. He even admitted to having toyed with the idea of discovering the secret of perpetual motion.

Whether he made much progress in making such a machine, a goal that most scientists regard as impossible, he nevertheless did build a shop next

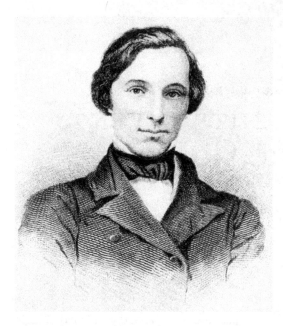

James Legare. *The Knickerbocker Gallery,* 1855.

to the Laurens Street cottage, and therein he set about playing the part of amateur scientist. Yet, his was not a monomaniacal devotion to the laboratory; indeed, graced with what has been described as "dark good looks and intense personality," Legare attracted the attention of a number of young women in the area, and he eventually chose as his wife Anne Andrews of Augusta, Georgia, whom he married in the spring of 1850.

All the while, his scientific pursuits were producing results, including a type of encaustic tile that could be used for flooring and an inexpensive, non-soluble putty for use by glaziers. The invention that elicited the most public curiosity, however, was what he described as a "plastic fibre of great variety of application, best known as plastic cotton, though cotton is one of its resources."

Seven years in the making, Legare called the product "lignine." Essentially, he took the common cotton fiber and mixed it with certain chemical agents— these include alum, gypsum, sulfate of protoxide of iron and sulfate of lime in various proportions—to create a substance that could be worked into any shape, either by hand or with a lathe. When dried, lignine was, according to its inventor, durable and lustrous.

At first, Legare himself set about using lignine for "household ornamental work." He constructed a mantelpiece, still to be seen in the Laurens Street cottage. He also fashioned a number of pieces of furniture, some of which are now in the possession of the Charleston Museum. In fact, the museum has catalogued seven pieces of plastic cotton furniture, all donated by Emma Susan Gilchrist in 1919; she presumably received them from Legare's brother Joe.

Three are now in what the museum describes as "extremely bad condition," but four are in better shape. The two most impressive examples are a curio cabinet almost seven feet tall and three feet wide. Its wooden

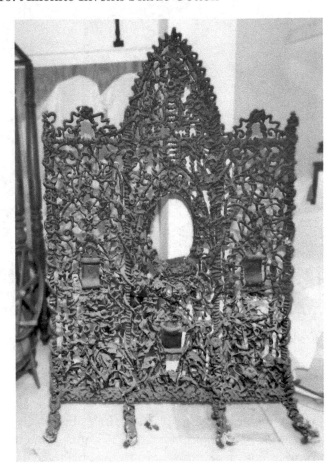

Fire screen decorated with plastic cotton. *The Charleston Museum.*

frame is covered by black cotton fiber decorations, including a helmeted bust at the top in the center, a niche featuring a figure of Petrarch beneath the bust with shelves on either side and a base featuring two kneeling monks framing a monochromatic rendering of Westminster Abbey. The other is an elaborate library screen approximately seven feet tall and five feet wide; its tripartite panel is composed of a mass of grape vines with interspersed cherubs, all made of cotton fiber over a metal framework.

In 1856, Legare traveled to Charleston to exhibit some of the products of his ingenuity at the annual autumn fair hosted by the Industrial Institute. He won a gold medal that year in the category of household furniture. The citation lauded lignine as an "invention worthy of great praise for its cheapness, durability and appropriateness. It has stood the test of several years of usage as furniture, is nearly incombustible, and becomes very hard by time."

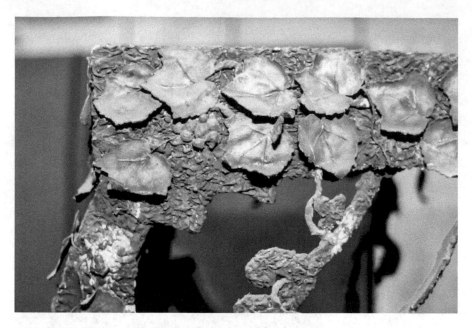

Detail of table with plastic cotton decoration. *The Charleston Museum.*

The next year, he returned to the fair with shingles made of plastic cotton. The November 21 issue of the *Charleston Courier* reported that Legare hoped to use the plastic cotton shingles on "a new hotel in Aiken and the new Methodist Church." He claimed that the roofing material was fireproof and economical since it could be made from "all refuse cotton of mills and plantations."

The same article also noted that a "temporary break down in health has caused some delay" in his fully implementing his schemes. This passing reference to Legare's chronic condition was a dire indication that he was once again experiencing "hemorrhage of the lungs."

Indeed, as his prospect for scientific success improved, his health deteriorated. At the 1857 Industrial Institute Fair in Charleston, he won silver medals for his tiles and plastic roofing and a "diploma" for his glazier's putty; and by the end of the year, he had been granted a patent for "Improvement in Preparing Plastic Cotton for Moulding Purposes." Yet, at the same time, visitors to the Laurens Street home found Legare "lying still in a critical state."

At this point, he was trying desperately to find a partner to manage his affairs and investors to finance the manufacture of his inventions. His mind brimmed with marketing ideas; he even envisioned the construction of

whole buildings "put up in a prominent place in Augusta, entirely of plastic fibre, walls, roof and all."

In some of the frequent letters that he wrote at this point to J.H. Hammond, who at that time was dividing his time between his showcase plantation Redcliffe and Washington, D.C., where he was serving in the United States Senate, Legare blamed his failure to recover from the disease that was wracking his body on the worry occasioned by his not being able to exploit his discoveries. He tried a number of desperate "remedies," including facial bloodletting, but nothing helped. On May 30, 1859, at the age of thirty-five, James Mathewes Legare died; he is buried in the churchyard of St. Thaddeus Episcopal Church in Aiken.

Had he lived long enough to fully exploit his discovery, Robert Jacobs, an authority on Southern belles-lettres, rather fancifully mused that "houses made of cotton might have covered the South furnished with cotton chairs and bedsteads, with cotton busts of Cicero and Demosthenes on stands made of cotton in libraries whose very shelves were made of cotton!"

Chapter 9

1853: COUNTY OFFERS SANCTUARY TO NINETEENTH-CENTURY BOTANIST

The crest of the vertical headstone that marks the grave of Henry William Ravenel is adorned with a single rose. It might more appropriately have been a fungus if the unknown carver in 1887 had been industrious enough to find an image of one of the two hundred species of the genus *Ravenelia* named after the South Carolina botanist.

Curiously enough, the same year that the Reverend Miles Joseph Berkeley in England named the genus for Ravenel, who had lavished specimens of unusual South Carolina fungi on his British counterpart for years, also marked the latter's removal from his family's Lowcountry plantations to Aiken. It was 1853.

For the next thirty-five years, Henry Ravenel was to call Aiken his home, and it was here that he oversaw the publication of five volumes of his landmark *The Fungi Caroliniani Exsiccati*, a series that established the Aiken-based botanist as the world's leading authority on North American fungi. Thirty copies of the book were printed, each one containing one hundred labeled specimens, pressed between sheets of blotting paper, coated with poison to preserve them from insects and glued to each sheet.

Born in 1814 at Pooshee Plantation in Berkeley County, Ravenel received his early education at the Pineville Academy and entered South Carolina College—now the University of South Carolina—as a sophomore at the age of fifteen; he graduated in 1832. At first thinking that perhaps he wanted to become a physician like his father, he became a planter by default when his father, thinking that his son's health was too delicate for the rigors of medical

study, deeded him a nearby plantation. Thus, his day-to-day responsibilities revolved around the successful management of Northampton Plantation. Thanks to his early enthusiasm for marl and other fertilizers, Ravenel was able to rejuvenate the depleted soil that he had inherited and once again make the property profitable. His free time, however, he spent immersed in his cherished avocation, exploring the undisturbed woods and swampy areas on his land for the purpose of collecting and classifying novel examples of fungi, mosses and lichens. At first, he told others that he disliked even touching fungi because they reminded him of "toads and lizards," but he soon came to admire them for their beauty, especially their subtle variations in color.

Nevertheless, by the fall of 1851, his health had deteriorated due to some form of stress-related indigestion, and his friends began suggesting possible remedies. The novelist William Gilmore Simms, for one, prescribed taking a cold bath each morning and drinking at least one glass of cold water daily. Others counseled a change of climate and touted the growing reputation of Aiken as a health resort. Those suffering from tuberculosis had found the climate salubrious, and the direct rail line from Charleston to Aiken made the latter an easy destination; perhaps, they argued, the drier air would have a similarly beneficial effect on those in thrall to dyspepsia.

Thus, two years later, Henry Ravenel decided to move his family to Aiken. He sold Northampton at a good price and rented a home on what he called "Aiken Heights" until he could purchase his own farm. Ravenel named his new property, located one mile outside of town, Hampton Hill, and he set about improving his investment by planting peach trees and cultivating grape vines: four thousand of the former and somewhere between six and eight thousand of the latter. In fact, his health improved and his optimism restored, Ravenel soon became a leading light among those interested in the art of cultivation, even serving for a time as an officer in the Aiken Vine-Growing and Horticultural Association.

Ravenel also joined the congregation and choir of St. Thaddeus Episcopal Church and became acquainted with some of the leading citizens of the town, including James Mathewes Legare. One of Ravenel's daughters—he had four children by his first marriage and five by his second—took drawing lessons from Legare in the cottage that still stands on Laurens Street. Ravenel himself invested in some of Legare's manufacturing schemes, one involving "improvements" to "hanging window shades" and the other related to the invention of plastic cotton or "lignine."

His years in Aiken witnessed the end of one marriage and the start of another. His first wife, Elizabeth Snowden Ravenel, died in 1855, and he

Henry Ravenel carte de visite, 1861. *South Caroliniana Library, USC.*

married Aikenite Mary Huger Dawson in 1858. She was then twenty-five and he forty-four.

By all accounts, the War Between the States brought financial ruin to Ravenel. He himself was excused from military service; his personal physician asserted that he suffered from inflammation of the intestines and that "any active exercise or exertion," such as "walking or riding on horseback," would inevitably be followed by "great prostration and weakness." If that were not enough to disqualify him for active service, he was also almost completely deaf and his eyes were weakened by the strain of staring long hours into a high-powered microscope that he had ordered from France.

Nevertheless, short of active service, he tried to make a contribution to the war effort. He invested—unwisely as it turned out—much of his money in Confederate bonds; and he tried to offset widespread food shortages by advocating alternative sources of nourishment. He contributed, for example, an article on cottonseed coffee to an issue of the *Charleston Daily Courier* in April 1862 and another piece entitled "Edible Mushrooms of the Country" to the *Southern Cultivator*, an Augusta periodical, in October of that same year.

Interestingly enough, however, when the war came to Aiken County in 1865 in the form of a Union cavalry force under the command of General Hugh Judson Kilpatrick, Henry Ravenel was visiting his family's Lowcountry plantations, and so he missed being a possible eyewitness to the Battle of Aiken. In her diary, his daughter Charlotte wrote that her family desperately wanted to return to their farm outside of town but fears that General Sherman's forces had destroyed the railroad outside of Orangeburg

kept them stranded where they were. In this same document, however, she does refer to letters from Aiken neighbors who claim that the Ravenel house was broken into by some soldiers assigned to General Joe Wheeler, the Confederate hero of the battle. The men in question took "all of the carpets, blankets, and provisions," including approximately fifty bushels of corn and twenty-two gallons of homemade wine. Ravenel's desk was also damaged and his papers scattered. Charlotte Ravenel notes the irony of having been plundered by one's own people, but so poorly supplied were Confederate soldiers during the last days of the war that they sometimes took matters into their own hands.

The Ravenel family, then resident at Pooshee, did not escape their own first-hand encounter with Union forces. In fact, they may have been subjected to as many as a half dozen visits, including one raiding party that confiscated horses, wagons, poultry, wine and the contents of both the smokehouse and the root cellar. The house itself was not touched nor the family's food supply therein; the silver had already been buried on the grounds and other valuables stuffed into mattresses. Furthermore, not every incursion of Northern soldiers on their land brought distress; indeed, Ravenel himself writes of the gentlemanly behavior of some of the officers, including General Edward E. Potter, then in command of most of the Union forces in the area.

In the years immediately following the War Between the States, Ravenel found his finances in shambles. He had no one to pick the peaches and grapes on his Aiken farm and no way to get those fruits to market since the railways were destroyed. Instead, for ready cash, he turned to what had once been an avocation: his knowledge of botany. He began collecting specimens for other scholars, who would pay him for his work; and he started a nursery to begin generating his own supply of seeds to sell to European horticulturalists. He also tried to earn a living by the pen; he wrote an agricultural column for the *News and Courier* in Charleston and for a Charlotte-based journal entitled *Land We Love*.

Although his later life brought him relatively little financial reward, scholarly accolades were heaped upon him. In 1883, he was elected to membership in the Imperial Zoologic-Botanic Society of Vienna, Austria; and in 1886, he was granted an honorary doctorate by the University of North Carolina at Chapel Hill. After his death, his wife sold part of his herbarium to the British Museum and part to Converse College.

Henry Ravenel is buried between his daughter Charlotte and his second wife, Mary Huger Dawson, in the churchyard of Saint Thaddeus Episcopal Church on the corner of Richland and Pendleton Streets in Aiken. Carved

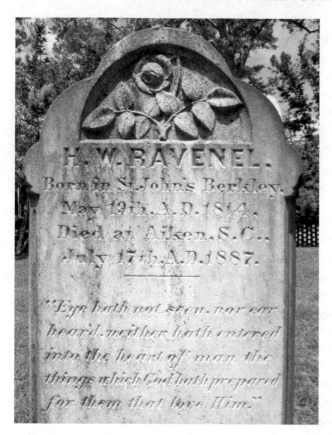

Ravenel gravestone. *Tom Mack.*

on his granite marker is a quotation from the First Epistle of Paul to the Corinthians: "Eye hath not seen or ear heard. Neither hath entered into the heart of man the things which God hath prepared for them that love Him." For an individual whose intellectual pursuits frequently offered respite from physical and financial hardship, this biblical assurance must have provided additional comfort.

Chapter 10

1865: Two Principal Adversaries at the Battle of Aiken Were "Frenemies"

I don't care about Aiken unless you can take it in a dash," instructed General William Tecumseh Sherman to his cavalry commander Hugh Judson Kilpatrick during the invasion of South Carolina in February 1865. "Only attack Wheeler when he exposes himself."

Thus, Kilpatrick, under orders principally to disrupt the rail lines along his route from Blackville, advanced toward Aiken. Some say he targeted the Graniteville Mill, where William Gregg made cloth for the Confederacy, or the giant powder works in Augusta; it is more likely, however, that Kilpatrick was in pursuit of one of the things he liked best—a little mischief.

A late and not entirely expected arrival in the family—his mother had been married twenty years before giving birth to him in 1836—Kilpatrick was a spoiled child, used to dominating his surroundings despite the fact that he grew to a height of only five feet five inches. Given his height and slight build, he made an unlikely candidate for West Point, but with some savvy manipulation of political connections in New Jersey, he was admitted. Because of his shortness of stature, large nose and wide mouth, he was often the butt of his classmate's humor, but Kilpatrick managed to shake off their gibes and excel in his undergraduate preparation due largely to sheer will and an overpowering self-confidence.

Curiously enough, one of his fellow cadets and future adversaries was Joseph Wheeler, who was also, for a time, one of Kilpatrick's best friends. Wheeler was also short, the same height as Kilpatrick; and the two young men may have formed an alliance based partially on that fact. Could it be that they both

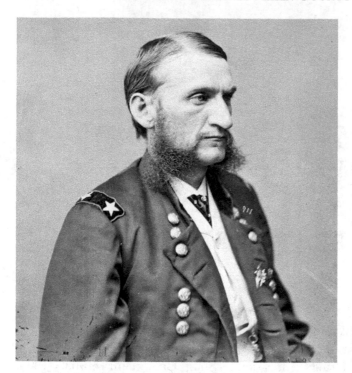

Hugh Judson Kilpatrick. *Library of Congress.*

suffered from what is sometimes called the Napoleonic complex? Can the nature of their subsequent military careers be traced to the tendency of some short males to overcompensate for their lack of height by being overly aggressive?

In some ways, they were very different—Kilpatrick was talkative while Wheeler was quiet and soft-spoken; still, they both earned reputations for fearlessness. Kilpatrick's nickname was "Kill-Cavalry" because he was not averse to endangering his men in the pursuit of personal glory; Wheeler became known as "Fightin' Joe," a sobriquet he earned while defending a wagon train from an Indian attack in 1860, one year before he swore allegiance to his native Georgia after that state seceded from the union.

Both old friends found themselves in opposing positions after General Sherman selected Kilpatrick to lead his cavalry forces following the fall of Atlanta in 1864; Sherman did not always like the fact that Kilpatrick often pursued his own course of action but he nevertheless approved of his "zeal and activity." Time and time again during Sherman's march to the sea and his subsequent invasion of South and North Carolina, Kilpatrick and Wheeler skirmished.

They also exchanged letters. "As soon as the weather permits, I will pay you a visit," warned Kilpatrick in one missive. "Come ahead when you are ready," replied Wheeler. "We will give you the warmest reception you ever had."

1865: Two Principal Adversaries at the Battle of Aiken Were "Frenemies"

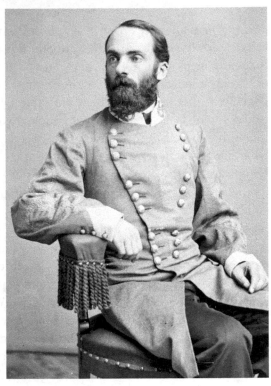

Joseph Wheeler. *Library of Congress.*

Not all of their correspondence was marked by battlefield humor. After hearing that Kilpatrick's raids on Confederate lines of supply and communication had expanded to include the plundering and burning of private residences, Wheeler beseeched his old classmate to "offer some protection to the families necessarily left defenseless and not leave them at the mercy of brutal soldiery." For his part, Kilpatrick refused to take all the blame for the depredation of the civilian population: "I will say that the same complaints have been made by the citizens of Georgia against officers of your own command." Indeed, Wheeler's men, always short on supplies, especially near the war's end, frequently took what they could find (note Charlotte Ravenel's account in the preceding chapter).

In truth, both men were accused of running rather untidy camps and exerting rather lax discipline. Kilpatrick was notorious for his womanizing— he had both white and black prostitutes often in tow. Of the marauding habits of Wheeler's men during Sherman's march to the sea, Georgia statesman and erstwhile Confederate secretary of state Robert Toombs said, "I hope to God he [Wheeler] will never get back to Georgia."

In the final analysis, however, Kilpatrick's men were a far more destructive force than Wheeler's, particularly in South Carolina. Famous is the message that he sent to General Sherman on February 7, 1865, after the leveling of twenty-nine buildings in a single municipality: "I changed the name [Barnwell] to Burnwell." Much the same fate may have been in store for Aiken when on February 11 Kilpatrick advanced on the town after news that Wheeler was in the vicinity. Most accounts agree on the basic facts of what happened next. Wheeler had presumably set a trap for the impetuous Kilpatrick, using a small portion of his force to draw the Union cavalry into a pincer of sorts as they approached the town from the east.

The trap, however, did not take into account the fact that units under Kilpatrick's command had considerable space between them, so only the advance guard was initially surrounded, resulting in a period of fierce hand-to-hand combat before the Union troops were forced back toward Montmorenci.

Kilpatrick never admitted that he had experienced a defeat; in fact, he called the whole affair a "reconnaissance." Whatever the appropriate term might be to describe what happened in downtown Aiken, it was not long before Kilpatrick was back to the business of destroying rail lines, joining the main Union force as it advanced on Columbia.

What happened to both men after the war? Kilpatrick went back to New Jersey where he became a successful farmer and a popular lecturer on his wartime experiences. He ran unsuccessfully for the governorship of his state—many prominent veterans of the war ran for political office—and he twice served as our country's ambassador to Chile, once during the Johnson administration and again under Garfield. It was during his second stint in the diplomatic service that he died of kidney disease in 1881 when he was only forty-five.

After spending some time in federal prison—he was captured by Union forces trying to rendezvous with Jefferson Davis in the latter's flight south after the fall of Richmond—Wheeler, who was not quite thirty when the war ended, married a woman of means and settled, for a time, into the comfortable life of an Alabama planter. Like Kilpatrick, he heard the clarion call of politics, and he served several terms as a U.S. congressman from his adoptive state. Finally, at the age of sixty-one, he volunteered for military service at the outset of the Spanish American War and served as a gray-bearded major general in both Cuba—Teddy Roosevelt's Rough Riders were under his command—and the Philippines. He died in 1906.

Thus, both of the principal adversaries at the Battle of Aiken survived the war to make significant contributions to the welfare of their now-reunited country.

Chapter 11
1865: Civil War Memoirist Calls Aiken His Home

O f the numerous eyewitness accounts of the War Between the States, most penned by military leaders and politicians, one book stands out. The volume in question, Arthur P. Ford's *Life in the Confederate Army*, is noteworthy not only for its point of view of a common soldier in the midst of the conflict but also for its local connections—the author was a South Carolina native who eventually called Aiken his home.

Born in Charleston in 1843, Arthur Peronneau Ford left a comfortable position as a post office clerk to join the Palmetto Guards. From April 1862, when he was only eighteen, until April 1865, when General Joseph E. Johnston surrendered to General Sherman in North Carolina, Ford provided faithful service to the Southern cause, mostly in his home state.

For most of his three years in the army, he was assigned to an artillery unit in defense of Charleston, and over half of his memoir describes skirmishes—he calls them "affairs"—with Federal gunboats engaged in blockading the port and harassing Confederate forces on the barrier islands surrounding the city. Stationed mostly on James Island, Ford was often in the thick of the action, manning a howitzer trained on enemy vessels or serving as lead driver of a team of horsemen charged with repositioning one of the big guns.

He was also an eyewitness to some of the most dramatic events in the protracted siege of Charleston. Ford saw the now-legendary "torpedo submarine boat," the *Hunley*, as it proceeded up the Stono River on one of its tragic practice runs; he was also camped less than a mile from Battery Wagner

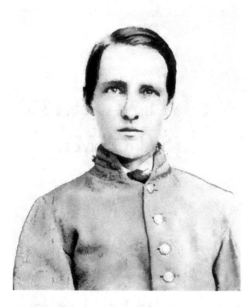

Arthur Ford. *Aiken County Public Library.*

during the assault by the Fifty-fourth Massachusetts Infantry on that Confederate fortification made famous in the film *Glory*. He describes how the "mass of blue sprang up apparently from the earth" and how the guns at Fort Sumter fired at the beach in front of the fort. During the twilight assault, according to Ford, "the rapid fire of musketry" was "like vast masses of fireflies."

Besides his first-hand account of military engagements—after the evacuation of James Island in February 1865, Ford's unit joined other Confederate troops in trying to counteract Sherman's advance through the Carolinas; he fought in the Battles of Averasborough (during that engagement his blanket roll and a jacket button deflected a Yankee bullet) and Bentonville—the book is interesting because of the author's attention to the details of everyday life in camp and on furlough.

Ford pays particular attention to his diet and to his feet. In the former regard, he sometimes rails against the Confederate commissary's inability to properly provision the men in the field. For a two-month stretch on James Island, for example, his own unit had to make do with only one loaf of bread and a "gill" or quarter of a pint of sorghum syrup per man per day; during the time the troops were in pursuit of Sherman's forces, each man was rationed only seven ounces of bacon and a pint of cornmeal per day; very often during the last months of the war, Ford and his comrades had to beg for food at farmhouses en route.

As to his feet, Ford had somehow learned the old adage that "a marching man is no stronger than his feet." Even though many of his comrades were often shoeless, Ford managed to keep his "uppers" and soles together by binding them with "several leather strings," and he bathed his feet daily to prevent blistering.

In general, Ford seems to have been more attentive to his personal health than many of his compatriots. For example, he regularly ingested quinine while

1865: Civil War Memoirist Calls Aiken His Home

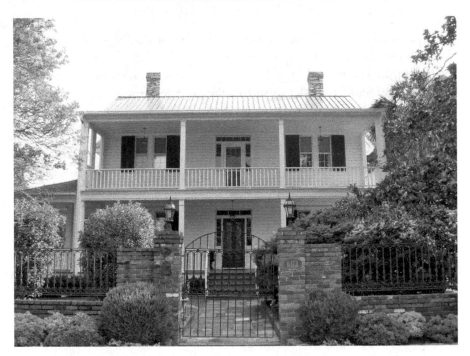

Ford House. *Tom Mack.*

on duty in an abandoned rice field near Green Pond, South Carolina, where the "most serious disturbers" of the peace were the voracious mosquitoes.

Although he escaped even a "touch of fever" during that assignment, twice Ford had to be sent home on furlough due to illness, once in March 1864 when he was given thirty days to visit his parents and sisters in Aiken and again in early April 1865. On both occasions, he describes the ordeal of wartime train travel in the South: "worn-out tracks and roadbeds" and "dilapidated engines and cars." On his second and final journey home, Ford witnessed President Jefferson Davis and his cabinet on their flight westward to "continue the war across the Mississippi."

Following a circuitous route from North Carolina through Newberry and Abbeville in South Carolina and then Washington and Augusta in Georgia, Ford finally made it home to Aiken where Federal troops—African American soldiers under the command of a German-speaking officer—maintained martial law.

In the years after the war, Ford published the *Aiken Recorder*, a semi-weekly newspaper in print from 1881 to around 1910—an 1889 advertisement indicates that the annual subscription was a dollar and that half of that

amount was to be paid "in advance." His *Life in the Confederate Army* was published by the Neale Company in 1905.

In the mid-1880s, Arthur P. Ford built a house on Barnwell Avenue, an imposing residence that stands to this day as a testament to the resilience of a self-described "enthusiastic, energetic youngster" who survived "the great war." He is buried in the churchyard of St. Thaddeus Episcopal Church in Aiken.

1868: QUAKER SPINSTER BECOMES IMPORTANT CIVIL RIGHTS ADVOCATE

A native of Bucks County, Pennsylvania, Martha Schofield was one of a score of Quaker women who decided that the education of emancipated slaves was their calling. In her particular case, Schofield had the support of her parents, who were ardent abolitionists, and a family lineage that included at least one resolute ancestor who was burned at the stake for his beliefs.

In later years, Schofield herself often referred to this sixteenth-century progenitor as a role model when she was questioned as to why she was so adamant in her determination to do what she thought right regardless of the consequences. Thus, in 1862 after the Union army captured the Sea Islands, the twenty-six-year-old Schofield volunteered at the behest of the Pennsylvania Freedmen's Relief Association to teach former slaves on Wadmalaw Island to the southwest of Charleston. That term of service was followed by another on St. Helena where she caught what was then called climatic fever.

Seeking a healthier environment, she did what so many others, such as James M. Legare and Henry Ravenel, had done before her: Schofield headed for Aiken in 1868 because of its reputation as a health resort. Never to remain idle for long, she quickly went into partnership with others to start a school before conceiving of the idea of going it alone.

In 1871, using her own savings, she bought the land; the building she paid for through funds solicited across the country. Thus, the Schofield Normal and Industrial School came into being. There were two basic curricula: one focused on preparing teachers and the other focused on vocational

Martha Schofield. *Aiken County Public Library.*

education. Students in the former program were generally older—at the beginning, the ages ran the gamut from five to thirty years—and they studied traditional academic subjects: reading, spelling, arithmetic, geography, history and religion. Ten years of study were required to complete the teacher-training curriculum, which also involved, as the student progressed through the program of study, lessons in pedagogy, "school economy" and some practice teaching on the younger pupils.

As the early hopes for black political power faded after the 1876 and 1880 elections, which returned control of the state to the planter class that had held the reins of power before the war, Schofield put greater emphasis on helping the local African American population gain economic power through vocational education, including instruction in the following subjects at various points in the evolution of the institution: printing, carpentry, cobbling, caning, blacksmithing, harness making and agriculture. The official motto of the school was the one word "thorough," and Schofield wanted her students to apply that term, as she did in her own life, not only in their academic pursuits but also in their daily lives.

Her plans for a model institution were, however, not greeted enthusiastically by the local white population, which resented the invasion of Northern teachers in the town and saw their work as not just philanthropic but propagandistic—they were accused of spreading the gospel of social equality to freed blacks. As a prominent figure in the town, Schofield soon found herself embroiled in the political turmoil of the times.

Following the Ellenton Riots of 1876, for example, a local minister, perhaps worried that news of the violence in Aiken County might hurt the tourist trade, sent a letter to the *New York Daily Tribune* in which he asserted that everything was tranquil in the town. Outraged by what she saw as an attempt to hide the truth, Schofield dashed off a rebuttal to the same publication;

entitled "South Carolina Not at Peace," her letter, published on November 15 of that year, offered detailed examples of the political intimidation carried out by white rifle clubs against the local blacks—she is said to have personally offered shelter to an eyewitness of the mayhem in Ellenton.

Her letter set off a firestorm in the press. It was soon followed by a missive signed by fourteen "leading men" of Aiken, attacking her "credulity" in believing the one-sided accounts that she had heard and charging her with fanaticism "imbued with the spirit of antislavery in the most extreme form."

Schofield, however, was not to be silenced. She continued to tell what she saw as the truth, and her letters were copied in other papers across the country; it may indeed be argued that her epistolary efforts ensured that news of the political violence in Aiken County would not be suppressed in the national media.

Martha Schofield paid a price for her outspokenness. She received hate mail from local citizens—some said that her own teaching led to the racial conflict that she described—and threats of violence—a group of armed men appeared on her porch one evening but dispersed when she came to the door. The local paper, the *Aiken Journal and Review*, featured editorials about her with such statements as the following: "We really do not think we would be much to blame if we expelled this author from our midst."

As the local paper also pointed out, Schofield had been largely "ostracized" by the local white population; only Northern visitors appeared to take an interest in her activities. Yet, it would be years before the winter colonists offered their financial support; it was not until 1906, after Hope Goddard Iselin, the "Hope" of Hopelands Gardens, paid a visit to the school, that "that set," according to Schofield, began to make donations on a regular basis.

The concerted opposition of the local white population seemed only to strengthen Schofield in her resolve, and the local paper eventually decided to end its smear campaign so as, they asserted, "not to put her any more in the light of a martyr which is undoubtedly her wish." Schofield may have indeed relished this testing of her determination, but she also agreed with Frederick Douglass that slavery had been a curse not only to the enslaved but also to the slave-holding class, and she judged that it would take "this generation and the next before the stains can be wiped out." Thus, her letter writing may have been an extension of her educational mission; she hoped that by standing witness to the full story she might aid in the "reformation of attitudes" and in lifting "the darkness of ignorance [that] hangs like a shadow over this southern country."

Schofield paired her quest for racial equality with an ardent support of women's suffrage; she felt that once given the vote, women would lead

Bell tower. *Tom Mack.*

the way to end racial discrimination. In 1895, she sponsored a speech by Susan B. Anthony at the Aiken County Courthouse; and she lobbied for the inclusion of a woman's right to vote in the state constitution, which was being revised that year. That effort failed.

Nevertheless, she continued to devote time and energy to both efforts, educational reform and women's suffrage, while concurrently serving as business manager of her school. By 1910, the institution took up two city blocks in the city of Aiken and was heralded across the country for the efficacy of its programs.

She died in Aiken in 1916 and is buried in Darby, Pennsylvania. Her school was absorbed into the county system in 1952, and the original cupola or bell tower that once sat atop Carter Hall, built in 1882, still survives in the central courtyard of the present building on Kershaw Street.

Another interesting artifact of her life and times is in the collection of the Aiken County Historical Museum; it is a handmade phrenological chart, the written record of her "examination" by phrenologist Alice Stockton in

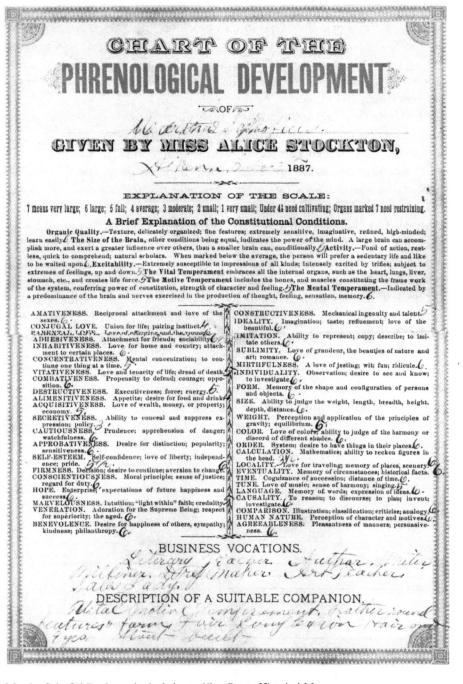

Martha Schofield's phrenological chart. *Aiken County Historical Museum.*

Aiken in December 1887. That month Stockton "read" Schofield's skull to get some sense of her character traits and mental faculties. It was believed that by using the fingertips and the palm of the hand to feel for lumps and indentations, one could make a determination regarding twenty-seven aspects of personality.

This early form of neuroscience, now discredited, was popular in the nineteenth century. In this particular case, given what was already public knowledge about her client, it is not surprising that Stockton would come up with some of her conclusions. First of all, the phrenologist gives Schofield high marks, scores of six out of a possible seven, for brain size, "mental temperament" and "activity"—meaning fondness for action and scholarly aptitude. On the other end of the scale, Schofield gets low scores for "conjugal love" or "pairing instinct"—since she was fast approaching fifty and had never been married, this was also a safe bet. Low scores meant that those capacities "needed cultivating."

The bottom of the chart offers two prescriptive lists: what business vocations the subject might pursue—Schofield's fell into two categories: teacher or milliner—and how to identify a suitable companion. In the latter regard, Schofield was directed to be on the lookout for someone of "vital amative temperament," "stout" build, "rather round features" and "fair complexion, hair, and eyes." As fate would have it, Martha Schofield never found her "suitable companion"; instead she devoted her life to what she saw as a much higher calling than matrimony—the advancement of education and social justice.

1870: CROFT LEAVES HIS STAMP ON HIS ADOPTED COMMUNITY

Downtown Aiken has a great deal of architectural diversity, including some fine nineteenth-century commercial buildings. One such structure, a two-story edifice at the corner of Laurens Street and Hayne Avenue, is of particular interest. Right in the middle of a small, purely ornamental pediment above the central entrance are the words "Crofts" and "Block" and the year 1884.

The Croft alluded to on the façade of the Crofts Block is George William Croft, who was one of the town's most influential citizens at the turn of the twentieth century. His personal story mirrors much of the early history of Aiken and this part of the state.

Born in Newberry County in 1846, Croft received his early education at what was to become during the time of the War Between the States the South Carolina Military Academy, a combination of two schools, the Arsenal and the Citadel. In 1864, when he was only sixteen, Croft was drafted into the service of his state when all the cadets were mustered to defend South Carolina against the invasion of Sherman's army. Croft became one of the "boy soldiers" employed by the Confederacy during the waning months of the war.

In 1862, the second year of the war, Abraham Lincoln outlawed the enlistment of young men under the age of eighteen, but there is plenty of evidence that many teenagers served in the Northern army by lying about their age and taking advantage of the less-than-scrupulous practices of some military recruiters; most of these Northern boy soldiers served as drummers

Crofts Block. *Tom Mack.*

or messengers. In the South, it was a different story, particularly as the war dragged on and manpower dwindled. There had always been plenty of underage volunteers, but in 1864, the Confederacy modified its official conscription policy by lowering the draft age to seventeen.

Croft survived the war to study law at the University of Virginia for two years and to benefit from further tutelage in the office of Benjamin F. Perry, a Unionist Democrat who was appointed by President Andrew Johnson to serve as an interim governor of South Carolina for five months in 1865.

After passing his bar examination in 1869, Croft set up law practice in Aiken. Thus, his relocation to that community roughly parallels the emergence of Aiken as a county seat—the county itself was created in 1871 by incorporating parts of Edgefield, Barnwell, Lexington and Orangeburg Counties. According to all contemporary accounts, Croft's law practice seemed to flourish; some records indicate that it may have been the largest such practice in this part of the state.

It is also certainly true that in the 1870s Croft became embroiled in Reconstruction politics by his decision to align himself with former Confederate general and cavalry commander Wade Hampton III, whose

campaign for the governorship in 1876 resulted in the return of home rule in South Carolina and the reestablishment of control by the planter class that had held sway in our state before the war.

Croft presided over the Aiken County Democratic Convention of that year; the delegates voted to adopt the so-called Mississippi Plan, which called for voting a straight party ticket without compromise. He also presided over a large rally on October 20, 1876, in downtown Aiken where General Hampton spoke. Arriving in a four-horse carriage and accompanied by an escort of one thousand mounted supporters, Hampton was greeted by a local choir of women and children singing the "Hampton Song."

During that tumultuous year, Croft was an active member of the Red Shirts, a white paramilitary organization supportive of Wade Hampton's bid to wrest control of the state from the hands of Radical Republicans. The Red Shirts resorted at times to violent intimidation of voters.

It was, however, ostensibly as the "captain" of a local rifle club that Croft came to be the principal defendant in a notorious federal court case adjudicated in 1877. The previous year, his club had participated in what has become known as the Ellenton Riots, a series of armed skirmishes between white and black forces that claimed a number of lives on both sides. He was one of twelve white men arrested for their involvement in the hostilities. The trial itself took nearly two weeks, and the principal charge laid against the defendants was the "intimidating, threatening, and endeavoring to hinder David Bush [one of the African American fatalities during the riots] from voting on account of his color."

There is no doubt that the riots, addressed in a subsequent chapter of this book, were fueled by unfounded rumors and high tempers on both sides, and that was the gist of the defense mounted by Aiken attorney Daniel Sullivan Henderson. He argued that the actions of Croft and the other defendants were not part of a conspiracy to deny African Americans the vote but rather a hasty response—most of the men, it was argued, had to borrow horses and guns on the spur of the moment—to what was mistakenly reported as black-on-white violence in the county. David Bush had been shot, Henderson concluded, not because the members of the Aiken rifle club were bent on keeping blacks from voting but because they were acting in response to an emergency situation.

Whatever the full facts of the case—one of the most effective prosecution witnesses reported that he heard David Bush plead for his life with the words: "Please, sir, don't shoot me, and I will vote any ticket you ask me to"—the twelve men were acquitted by a mixed-race jury of any wrongdoing.

With Democrats in firm control of the state by 1877, Croft more fully devoted himself to politics, serving in both the South Carolina House of Representatives and the South Carolina Senate. However, he never totally abandoned his law practice; the Croft Block on Laurens Street housed his office and that of other local attorneys.

The high or the low point of his law career, depending on one's perspective, was Croft's involvement in one of the most sensational murder trials in South Carolina history. Indeed, Croft was a leading member of the defense team in the trial of James Tillman, nephew of "Pitchfork" Ben Tillman, kingpin of state politics at the turn of the century. Lieutenant governor of South Carolina, James Tillman had made an unsuccessful bid for the state's highest office in 1902; his overwhelming defeat at the polls he eventually blamed on the anti-Tillman editorials written in the *State* newspaper by its publisher Narciso Gonzales, a native of Edisto Island and son of an expatriate Cuban revolutionary.

On January 15, 1903, on the corner of Main and Gervais Streets, right opposite the statehouse in Columbia, the two men crossed paths; and Tillman shot the unarmed Gonzales with a German luger, one of two guns that he carried on his person. Before he fell, Gonzales was reported to have said, "Shoot again, you coward." He died of a fatal wound to the abdomen four days later.

The ensuing trial caused considerable controversy because of its astonishing conclusion: Tillman was eventually acquitted of any crime. Some historians argue that the trial may have been won during the jury selection phase when the defense team successfully managed to load the jury with individuals whose political leanings favored the populist stance of the defendant's uncle. Others argue that the defense stacked the odds in their favor when they were able to get the proceedings moved from Columbia where Gonzales had popular support to rural Lexington County.

Whatever the truth may be in this instance, the defense team managed against all odds to get the jury to believe that Tillman had acted in "self-defense," by doing what any self-respecting man would do after being called a "liar, defaulter, gambler and drunkard" in print. In his closing arguments, Croft concluded that Gonzales had "brought his own destruction upon himself."

Most of the principal media in this state and other parts of the country, however, expressed outrage over what they perceived as a miscarriage of justice; some in the press believed that the jury, made up mostly of mill workers and farmers, had been manipulated by the defense into believing

that Gonzales had been an elitist motivated by personal malice to write what he did and that Tillman was a populist just defending his honor.

Thus, Croft's two biggest moments in the courtroom came roughly twenty-five years apart, first as a defendant in one of the most controversial trials of the 1870s and then as a defense attorney in one of the most notorious murder cases in state history.

What about his record as a legislator? During his tenure at the statehouse, Croft's most significant accomplishment was

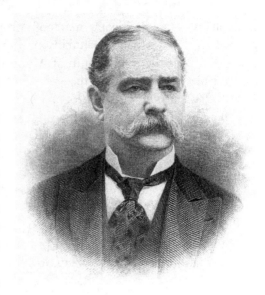

George W. Croft. *Aiken County Public Library.*

his advocacy of the first law in South Carolina prohibiting the employment of children under the age of twelve in factories; his impassioned speech on the floor of the statehouse presumably turned the tide against the cotton mill owners and their powerful allies.

Unfortunately, for all its good intentions, the law lacked teeth. It was very rarely enforced since there was no provision for factory inspections. Indeed, in 1909, photographer and sociologist Lewis Hine recorded children as young as seven years of age working in South Carolina mills. An individual was supposed to be twelve to gain regular employment, but often children lied about their age because their parents needed them to contribute to the family income, and many younger children could be found on the factory floor, "helping their older siblings." Those youngest of employees were not listed on the official payroll; their pay was given to their older brother or sister. Only in 1938, with passage at the federal level of the Fair Labor Standards Act, was the minimum age for factory work set at sixteen.

Still, Croft seemed naturally inclined to help the less fortunate, and one of his local efforts in support of that aim bore unblemished fruit. In 1877, he deeded property that he owned at the corner of York and Abbeville Streets in Aiken for the purpose of constructing an old folks home, which operated until 1966. The Croft Center on the current site bears his name.

Croft was a significant man of property, not only managing, in partnership with Mayhew Hankinson, a prosperous agricultural enterprise called Prospect Farm, just south of Montmorenci, but also owning a grand house called Courtland on the corner of South Boundary and Whiskey Road in Aiken. Part of the property adjacent to his homestead he sold so that the Aiken Institute could be built on that site; the building served as an elementary school from 1937 to 1986, and a wing added in 1913 was eventually repurposed as the county library.

George Croft died in Washington, D.C., in 1904, in the first year of his first and only term in the United States House of Representatives; the remainder of his congressional tenure was filled by his son Theodore Gaillard Croft. The latter met an untimely death of pneumonia at the age of forty-six. Both are buried in the St. Thaddeus Episcopal Churchyard on the corner of Richland and Pendleton Streets in downtown Aiken.

1876: GRANITEVILLE MURDER REMAINS SUBJECT OF ABIDING CONTROVERSY

B ecause of the popular and critical success of such works as *Blood Meridian* and *No Country for Old Men*, most readers might logically associate Cormac McCarthy with the Western novel. Yet, this towering figure of contemporary American literature once wrote a work set in Aiken County.

Indeed, in 1975, fledgling film director Richard Pearce wrote to McCarthy, then living in Tennessee, to see if he might be interested in dramatizing the few facts known about a violent crime that had taken place one hundred years before in the main office of the Graniteville Mill. It was the murder of James Gregg, the son and heir of Anglo-Scottish industrialist William Gregg, by Robert McEvoy, the son of Irish-Catholic millworker Patrick McEvoy. Gregg was shot at close range in the chest and abdomen in his office at the mill.

To Pearce's amazement, McCarthy responded positively to his inquiry, and the two men eventually spent time in Aiken County visiting Graniteville and interviewing local residents. What resulted from their collaboration was McCarthy's screenplay *The Gardener's Son*, published in 1996, and Pearce's motion picture of the same name, which premiered on PBS as part of that network's *Visions* series in 1977 and is now available on DVD.

Pearce's interest in the project can be traced to his reading the scant account of the murder in a footnote to the final chapter of Broadus Mitchell's biography entitled *William Gregg, Factory Master of the Old South*. Therein, the reader is presented with a largely motiveless crime, the senseless

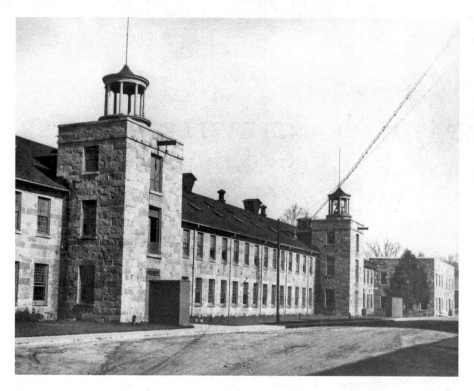

Graniteville Mill. *Gregg-Graniteville Archives, Gregg-Graniteville Library, USC–Aiken.*

act of a misfit. Reading between the lines of the official story and the official courtroom verdict, however, both Pearce and McCarthy try to give McEvoy a voice—the accused was denied a chance to speak in his own defense at the trial—and, in so doing, paint a picture of power politics in a small Southern mill town at the beginning of the Gilded Age.

The screenplay begins with Robert McEvoy's loss of his leg due to a railroad-related accident when he was only eleven. Because of infection, Marina Gregg, William's wife and the matriarch of the mill community, insists that her family doctor amputate the limb although young Robert claims that he would rather die. To counter his fear of being made "a cripple," Mrs. Gregg asserts, "God does not ask that all the flowers in his garden be perfect."

In part because of the trauma of this operation and in part because of his resentment over his family's displacement—like so many other millworkers, the McEvoys could no longer sustain a livelihood on the family farm and sought factory work to survive—Robert nurtures what his father describes as a "troubled heart."

A number of historians have asserted that many rural whites, accustomed to the work rhythms of farm life, may have been ill-suited to the highly structured regimen of the mill village; the population that some have called rather disparagingly the "cracker proletariat" was not accustomed to the enforced teamwork and time constraints of industrial production.

At the age of twenty, McEvoy flees the town only to return two years later when he receives news of his mother's fatal illness. "Older and harder looking and [wearing] a scar," he arrives too late to see her alive. What he does confront is the fact that his father, the company gardener, has lost his job working with the soil—an echo of his agrarian roots in Pickens County—and has instead become a servant of the machine.

The younger McEvoy also returns to a town no longer under the spell of the utopian vision of William Gregg, who hoped to establish an industrial empire that would not only make him prosperous but also better the lives of his employees. Instead, the son, James Gregg, comes across in the McCarthy/Pearce retelling as a man concerned only with the bottom line. Quality of the workplace as exemplified by the mill garden is supplanted by a blind focus on the profit margin. At one point, for example, Gregg asserts, "We have stockholders to answer to. We're not in the flower business."

Besides lacking his father's philanthropic bent, James Gregg, as depicted in *The Gardener's Son*, has a thinly disguised prurient interest in the female mill hands. Robert McEvoy, in particular, suspects that his sister Martha has been the object of Gregg's unwanted attention. McEvoy's enforced silence at his trial and the failure of any Graniteville resident to speak out about James Gregg's alleged sexual predation offer evidence of how comprehensively the mill owner's family dominates the town. The defense attorney tells Patrick McEvoy that "it won't do to attempt to blacken the Gregg name."

It is certainly true that McEvoy's fate was quickly decided—if not preordained by social circumstance. Depicted in the popular press as the bad boy of the village, allowed "to run crazy in the woods like an Indian," he pays for his presumably senseless crime by his swift execution. His distraught father buries him in secret, fearing that others might dig up his body to examine his skull for indications of criminal tendencies.

As for the body of James Gregg, his mother carries it off to Charleston with the exhumed remains of her husband, buried in 1867. She wants to have nothing more to do with the town that William Gregg established. Convinced now of the thanklessness of the millworkers, she even uproots the obelisk that once stood over her husband's grave in the Graniteville Cemetery. "I suppose I never understood that to an ingrate a generous person

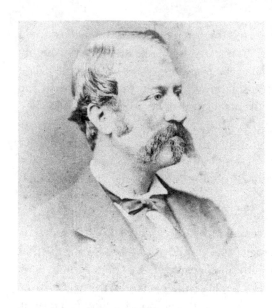

James Gregg. *Gregg-Graniteville Archives, Gregg-Graniteville Library, USC–Aiken.*

is a fool," McCarthy has her admit in the screenplay. The inscription on the monument proclaiming the senior Gregg as a "benefactor of the poor" seems to her now ironic in light of her son's murder at the hands of one of the people that her family hoped to save—the monument was, interestingly enough, returned to the village in 1926 at the behest of Gregg's daughter.

Both McCarthy and Pearce argue that through their manipulation of the official story, including written records and granite monuments, the Greggs tried to control history and that it is only through the agency of the creative artist—the novelist and the filmmaker—that a more inclusive picture of the past emerges. Certainly, for the poor and inarticulate, there is often no written or visual record.

In gathering material for this chapter, I visited the Gregg-Graniteville Collection at the library on the campus of the University of South Carolina–Aiken, which has in its possession documents and memorabilia of the Gregg family and the textile manufacturing firm that William Gregg established in 1845. In the library collection are also a number of personal items associated with James J. Gregg, including a metal box with his initials, books presumably from his days as a student at the University of Virginia and a framed portrait. A copy of that portrait accompanies this text; on the verso is written "Pelot and Cole's Photographic Gallery, 192 Broadway, Augusta, GA."

No known photograph of Robert McEvoy has come to light.

1876: MASSACRE AND RIOTS MARK RECONSTRUCTION POLITICS IN AIKEN COUNTY

In our country's centennial year, more than ten years after the defeat of the Confederacy, Radical Republicans, supported by newly enfranchised black voters and bolstered by the abiding presence of an occupying federal military force, still controlled South Carolina, but the tide was turning. One year before, white voters in Mississippi had wrested control of their state government from white and black Republicans through a systematic campaign of open intimidation and violence.

The so-called Mississippi Plan was soon to be adopted in South Carolina as a means of forcing out of the governor's office Daniel H. Chamberlain, the Massachusetts-born "carpetbagger" elected by a Republican majority in 1874. Ironically enough, Chamberlain was a moderate by nature with a keen desire to reform state politics by fighting the corruption and incompetence characteristic of much of the Reconstruction era. Time and again he fought his own party; time and time again he tried to reach across the aisle to white Democrats.

At the beginning of 1876, some of those Democrats were still arguing for a compromise ticket in the upcoming state elections, one that included cooperating Republicans; others argued for a "straight-out" ticket made up wholly of members of their party with former general Wade Hampton III at the top.

What tipped the scales in favor of the latter group was a tragic event that took place in Aiken County, a confrontation that came to be known as the Hamburg Massacre. As with all such polarizing incidents, this one has

elicited conflicting interpretations over time; however, most historians agree on certain basic facts.

On July 4, two white farmers, Henry Getsen and Thomas Butler, were on their way home to Edgefield after doing business in Augusta when they were stopped in Hamburg by a group of black militia in the process of drilling in the street. The partially deserted town had become a magnet for ex-slaves after the war and a source of irritation for the surrounding communities. Words were exchanged, but after some delay, the two men were able to proceed on their way.

Butler, however, later chose to sue the black commander Doc Adams, a former slave and Union army veteran, for blocking a public highway. Adams, for his part, countersued Butler for interfering with a military drill.

Prince Rivers, also a former slave and Union army veteran but now the local justice of the peace, tried to get both parties to settle the matter out of court, offering to have the militia surrender their arms in the care of Governor Chamberlain. When General Matthew Calbraith Butler, counsel for the initial plaintiff, avowed that he could not guarantee that peace could be maintained regardless of the outcome of the hearing, Rivers presumably advised the members of the militia on July 8 to barricade themselves in an old warehouse until tempers cooled.

By that time, hundreds of members of local rifle clubs had surrounded the building and began firing not only with the guns that they had brought with them but also with a cannon borrowed from compatriots in Augusta. They eventually blew a hole in the wall of the structure through which some militia escaped. At least one member, however, perished in the assault, and the rest surrendered.

That, unfortunately, was not the end of this sad affair. When members of the encircling mob discovered that one of their own had been shot and killed—a young man named Thomas McKie Meriwether of Edgefield— they became enraged, demanding retribution by selecting five of the men who surrendered and executing them on the spot. The rest were told to run as the white paramilitary force fired upon them.

Although a coroner's inquest called for the arrest of many of the leaders on charges of murder or "aiding and abetting" the commission of that crime, the attorney general of South Carolina postponed the trial until after the election. General Martin Witherspoon Gary—his former home is now a house museum in Edgefield—got all of the defendants out on bail. No one ever came to trial.

The Battle of Hamburg, as it was labeled by many of the locals, or the Hamburg Massacre, as it was termed by the outraged citizens of other

parts of the country, set the stage for the fall election. Even Wade Hampton III, who stopped short of advocating outright violence against his political opponents, still supported what he termed "bloodless coercion," like surrounding Republican rallies with mounted and armed men wearing red shirts, shouting down the speakers and firing their guns. It was not long before Governor Chamberlain himself gave up making public speeches while Wade Hampton III and his entourage marched triumphantly across the state to wild celebrations in all the key municipalities, including the town of Aiken.

On October 20, Hampton arrived in Aiken to address the citizens from a hastily constructed platform on Chesterfield Street; as he made his appearance on stage, bands from Graniteville and Augusta played, choirs of women and children sang and cannons were fired in salute.

Yet, peaceful celebration was not to remain the order of the day in Aiken County subsequent to the Hamburg Massacre. In early September, a second event took place within the borders of the county that drew national attention. The so-called Ellenton Riots were ignited by a false report—as was later determined—of a white woman being attacked by two black men in Silverton; news of this "outrage" circulated like wildfire throughout a three-county area. The two accused men sought the protection of the local black militia; white rifle clubs hastily gathered in response. Reports vary as to casualties; but it is estimated that three whites and up to fifty blacks were killed in two days of scattered violence.

This spate of lawlessness came to a head near Rouse's Bridge where a force of three hundred armed whites surrounded a group of one hundred black militia men. According to Captain Thomas Lloyd, who commanded two companies of federal troops that managed at the last minute to disperse the combatants, there was "undoubted evidence of a well-directed plan of attack, which, if carried out, would have resulted in the slaughter of all the Negroes in the place."

As fate would have it, the contested state election of that year—both Chamberlain and Hampton claimed victory—ultimately brought an end to the worst of the political violence but only after Hampton promised the newly elected President Rutherford B. Hayes that he would be personally responsible for restoring the peace and protecting the lives and property of all the state's citizens. With that pledge, Hayes withdrew federal troops from the statehouse, demoralized Southern Republicans were left to their own defenses and white home rule was restored.

White and black Republicans no doubt agreed with Daniel Chamberlain's assertion, "The Government of the United States abandons you." White Democrats, on the other hand, hailed Hampton's victory as the "redemption"

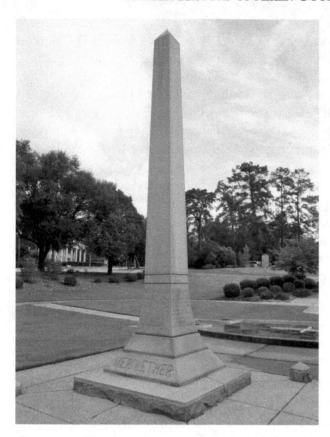

Meriwether Monument, North Augusta. *Tom Mack.*

of the state from both alien and black control. Regardless of one's personal perspective on the matter, the Hamburg Massacre and Ellenton Riots of 1876 set the stage for Hampton's election and the reassertion of white political control in South Carolina for the next century.

As an interesting footnote to this troubled period in county history, a monument to Thomas McKie Meriwether, the single white victim of the Hamburg Massacre, was erected in 1916 in Calhoun Park in the heart of downtown North Augusta; the base of the obelisk identifies Meriwether as a "young hero" who "exemplified the highest ideal of Anglo-Saxon civilization" and whose death "assured to the children of his beloved land the supremacy" of the "civic and social institutions…of his race." Now, at the beginning of the twenty-first century, local citizens question why there is no monument to the black men—A.T. Attaway, David Phillips, Albert Myniart, Moses Parks, Hampton Stephens and Nelder John Parker—who were also killed in July 1876. The debate continues.

Chapter 16

1887: The "Aiken Gamecock" Points the Way to the State's Constitutional Convention

During his lifetime, John Gary Evans set three records in South Carolina politics: he was the youngest person at twenty-five years of age ever to serve in the lower house, the youngest state senator at twenty-nine and the youngest governor at the age of thirty-one. He launched his record-breaking political career in Aiken.

Born in Cokesbury, South Carolina, in 1863, John Gary Evans had just the right credentials to enter postwar politics in South Carolina. He was the son of a Confederate general, Nathan George Evans, and the nephew of eleven other officers who served the Confederacy, including General Martin Witherspoon Gary, who became his guardian after the death of his father in 1868. Evans's father and uncle claimed the honor of escorting President Jefferson Davis to Cokesbury during the latter's flight south after the fall of Richmond; Davis spent a night in that town before moving on to Abbeville, where he presumably held his last war cabinet.

In 1868, the five-year-old Evans moved with his widowed mother to Edgefield to live with his uncle, General Gary, whose residence, Oakley Park, is now a house museum. Gary financed his nephew's education. He was a popular student at Union College in Schenectady, New York, until his junior year when he had to leave due to his uncle's death. Evans then took up the study of law under the tutelage of another uncle, William T. Gary, who was a judge in Augusta.

Evans eventually set up a law practice in Aiken in 1887. However, it was not long before he set his sights on a political career. This desire may have stemmed, in part, from his uncle's disappointment in that arena; after

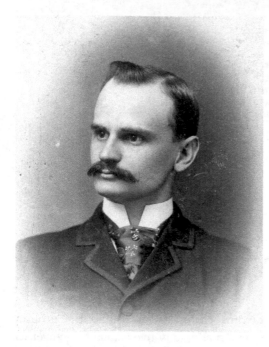

John Gary Evans. *South Caroliniana Library, USC.*

championing Wade Hampton III for governor in 1876, General Gary had expected to be rewarded with some political office. That was not to be.

His uncle's eventual disaffection for Hampton and the planter class that regained control of the state after Reconstruction may have informed Evans's own more populist political philosophy. Without a doubt, his early platform as a political candidate was based on helping the small farmer—many of his early legal cases involved collecting restitution from railroads for the loss of livestock—and railing against what he saw as corporate, especially Northern, financial exploitation of the agricultural South.

Historians are still on the fence about whether Evans's stands were heartfelt or opportunistic. By lineage and advanced education, he was certainly not a man of the people; and his later professional career would seem to contradict his public persona. In fact, he eventually became a railroad lawyer and capitalist—director of the Bank of Aiken and the Aiken Mining and Porcelain Manufacturing Company. Perhaps one could call him a political pragmatist; he assuredly saw which way the political winds were blowing in the state. They were blowing in the direction of Benjamin Tillman, one of South Carolina's most controversial chief executives.

Tillman's election as governor in 1890 brought to an end what many saw as a political oligarchy, control of government by a small group of interrelated Lowcountry aristocrats. Tillman stood publicly for the small farmer—and later the textile worker—in the Upstate. His election as governor brought to the surface what was, in effect, a class war simmering beneath the surface of state politics almost from the beginning.

As an elected official, Evans was widely perceived to have ridden Tillman's coattails. Certainly, during his terms in both the South Carolina House of

Representatives and the Senate, he pushed a Tillman agenda. Some of his causes might be labeled progressive. He did much to expand educational opportunities for the state's citizens by sponsoring bills allowing school districts to levy extra taxes in support of public education and opening South Carolina College (the University of South Carolina) to women. Other causes were clearly repressive; Tillman was dead set on suppressing the black vote and enforcing racial segregation.

Whatever his motivation, Evans became a legislative ally of Tillman's. By 1888, some called him the "whipper-in-chief"; an 1892 article in the Aiken paper referred to Evans as the "leader of the administration's forces in the legislature." Evans's devotion to Tillman seemed at times over the top; in a stump speech in Salley that same year, for example, he compared Tillman to Jesus Christ because of his support for the "masses of the South."

However hyperbolic his rhetoric might be at times, Evans proved to be an effective legislator. The high point of his senate career was his sponsoring the dispensary bill and seeing his proposal become law. In fact, the South Carolina Dispensary Act, which essentially established a government-run monopoly on the bottling and selling of all liquors in South Carolina, became known as "the Evans Bill." This compromise between regulation and prohibition was hailed as a brilliant achievement at the time, and although the state dispensary's twenty-year tenure ended with claims of political corruption, Evans was proud of his achievement, having spent, it is said, forty-five hours on his feet, actively engaged in parliamentary maneuvering to get the bill passed.

When Ben Tillman decided to run for the U.S. Senate in 1894—he was successful in unseating Old Guard incumbent and former Confederate general Matthew Calbraith Butler—the governorship was up for grabs. Although he publicly denied having a favorite in the race, Tillman could not have been displeased with the ascendancy of his protégé John Gary Evans.

Relishing his nickname "the Aiken Gamecock," Evans hit the campaign trail with a vengeance. Described as "wiry and vigilant" like the fighting rooster, he seemed to heartily enjoy debates with his opponents wherein he could proclaim his Tillmanite credentials. "All the thieves and scoundrels live in the cities and towns," he told one rural audience.

To make a long story shorter, Evans won the race. From the balcony at Crossways, his Aiken residence on East Boundary, it is claimed that Evans gave his acceptance speech. His administration is noteworthy for two accomplishments. Evans supported the construction of a South Carolina Exhibit at the Cotton States and International Exposition in Atlanta in 1895; that fair helped showcase Southern agricultural and technological progress

to a world audience. Both Evans and Tillman gave speeches at the opening of the exhibit, and they were both criticized in the press for bragging about their home state and for promoting sectionalism rather than nationalism.

That same year, John Gary Evans also presided over the convention to write a new state constitution, a document that still informs government practice to this day. Even though it has been amended hundreds of times since its initial framing, the 1895 constitution essentially granted more power to the legislature at the expense of the chief executive. Certain social stances were also imbedded in the original document—items generally no longer enforced—including limitations on the grounds for divorce and the stipulation that anyone who "denies the existence of the Supreme Being" is ineligible to run for the office of governor.

After his term, Evans tried unsuccessfully to run for the U.S. Senate in 1896 and 1897. With those defeats, his days as an elected official were over, but he remained active in the civic and business life of Aiken before he

Crossways. *Tom Mack.*

moved around 1900 to Spartanburg, where he lived with his wife, Emily
Mansfield Plume, the daughter of a Northern millionaire industrialist and
an ardent supporter of women's suffrage.

During the Spanish-American War, Evans volunteered for military service,
and he first served as inspector general, in charge of making sure that camps
in Georgia and Florida were properly run. During the occupation of Cuba,
he took control of the civil government of Havana, where he improved
general sanitation and set up a court system patterned after that of the
United States.

In his later years, Evans devoted himself to the internal workings of the
Democratic Party. He served as a delegate to the national conventions in
1900, 1912 and 1916; for ten years, from 1918 to 1928, he was an active
member of the National Committee.

One year before his death in 1942, Evans presented Oakley Park along
with forty acres to the town of Edgefield as a memorial to his uncle, General
Gary. He died in 1942 and is buried in Willowbrook Cemetery in Edgefield.

The fate of Crossways, his Aiken home, was in doubt for some time. Once
the center of an extensive agricultural operation before the War Between the
States, most of the surrounding land was eventually sold off and the grand
house fell into some disrepair until a relatively recent refurbishment. The
house was added to the National Register of Historic Places in 1997.

Chapter 17

1900: AIKEN LAUNCHES CAREER OF NATION'S "ASSISTANT PRESIDENT"

The *Time* magazine "Man of the Year" in 1946 was James Frank Byrnes. He was accorded the honor in part because he can be counted among the very few individuals to hold important positions in all three branches of the federal government. He was a legislator, serving as a U.S. Representative and then a U.S. Senator; in each house, he became a major player, first as an ally of Woodrow Wilson and then as a trusted confidant of Franklin Delano Roosevelt. For a short time, he was a Supreme Court justice. He also served in two presidential administrations, heading the Economic Stabilization Office and the Office of War Mobilization for FDR—it was for his significant contribution to the war effort that the press dubbed him the "Assistant President"—and acting as secretary of state under Harry Truman.

What many do not know about the extraordinary national and international career of James F. Byrnes is that it all began in Aiken when the eighteen-year-old left his native Charleston to make his way in the world. Only four years before, in order to help support his widowed mother, Byrnes had taken a summer job at a local law office and learned shorthand.

Acquiring that one skill had momentous consequences. As the result of a competitive examination, Byrnes secured in 1900 the post of stenographer to Judge James Aldrich of the Second Judicial Circuit, at that time a six-county district whose base was Aiken.

"Life was pleasant and sociable," writes Byrnes about the town whose "polo grounds and golf courses favored by many northern visitors lent it,"

he thought, "a cosmopolitan air." Although he himself asserts that he led a carefree bachelor life in Aiken, there is considerable evidence that even at his tender age, Byrnes had a strong work ethic.

He did indeed take part in the social activities available to young people at that time; he joined an organization called the Outing Club, which sponsored boating and swimming parties. At one of these outdoor excursions, he met his future wife, Aikenite and Converse College graduate Maude Busch. To spend more time with her, he took advantage of what he called his "barbershop tenor" voice and joined the choir at St. Thaddeus Episcopal Church where she was already a member. At first, he feared that his mother would disapprove—he had been raised as a Roman Catholic—but he eventually discovered that his mother preferred any church attendance over none at all.

Yet, during this same period of active courtship, Byrnes never stopped trying to make his mark in the world. While serving as court stenographer, he studied law under the tutelage of Judge Aldrich. In 1904, he passed the bar. That same year, in an effort to supplement his earnings, he even ventured into the publishing business, partnering with A.K. Lorenz to buy the semiweekly newspaper, the *Aiken Journal and Review*. Byrnes confessed, however, to leaving the management of the publication to Lorenz, and after only two years, he sold his share of the business to his partner.

In 1908, two years after his marriage, Byrnes decided to enter the political arena, running for the office of solicitor, a position akin to that of prosecuting or district attorney. Despite his youth, he won the Democratic primary, which was tantamount in that period of Southern history to winning the general election. His successful prosecution of several capital cases during the first two years of his term led supporters to urge him to run for the U.S. Congress.

That campaign in 1910 set the stage for much of Byrnes's later career since it honed his debating skills. Required of all Democratic candidates for federal office in the congressional district at that time was a public debate in each county—the Second Congressional District was composed of eight counties when Byrnes first ran for office. Thus, he traveled by train and by horse and buggy to each county and vied with his fellow candidates in delivering speeches that he himself described as being "as highly seasoned as the barbecues" that comprised the main menu items at such electoral events.

As fate would have it, Byrnes won that election by only fifty-seven votes. This slim victory was celebrated in Aiken by a torchlight parade whose participants carried banners that featured slogans such as "Fifty-Seven is Enough" and "I Love My Wife, But Oh, You Jimmie!" The event concluded

James F. Byrnes. *Library of Congress.*

with yet another speech, this one on the steps of the old post office still located at the corner of Laurens Street and Park Avenue.

That election ushered in fourteen years of service in the U.S. House of Representatives, a tenure that came to an end in 1924 when Byrnes left Congress to make an unsuccessful bid for a Senate seat. A year later, he left Aiken to join a law firm in Spartanburg; his public reason for this move was an admission that although he was a good lawyer, he was not a very successful bill collector. In fact, he often gave free legal advice to friends. His joining the larger Spartanburg firm meant that he could let others handle the business end of his practice, and he could devote himself to being a trial lawyer.

He remained in that profession until politics once again beckoned in 1930. The rest is history. Still, Byrnes never forgot Aiken, which he called home for twenty-five years, and Aiken never forgot him. In honor of his Aiken roots, a statue of Byrnes was eventually placed in front of the county courthouse; I devote a chapter to that work of art in my other book *Circling the Savannah: Cultural Landmarks of the Central Savannah River Area*, also published by The History Press.

1906: JAMES U. JACKSON REVISITS THE DREAM OF A TOWN ON THE RIVER

L ike Henry Shultz roughly eighty years before him, James Urquhart Jackson was a dreamer. Just as Schultz had envisioned a city rising on the riverbank opposite Augusta, so did Jackson, even as a boy, imagine a town where none stood at the turn of the twentieth century.

Born in 1856 in Harrisonville, which later became part of Augusta, Jackson would appear to have had every advantage growing up. His father was a man of means, at one time serving as a director of the Georgia Railroad Banking Company and later as a founder of the Enterprise Mill, a textile plant established in 1877 to take advantage of the water power made possible by the construction and further enhancement of the Augusta Canal.

As the son of a prosperous businessman, Jackson could look forward to a bright future, and he tackled his early studies with enthusiasm, graduating from Richmond Academy in Augusta and subsequently from the University of Georgia with honors.

In 1876, he set up a brokerage house named Vergery and Jackson with one of his school chums; among the securities he handled were railroad bonds. It is not surprising, therefore, that so many of his personal investments and his own career would involve the construction and operation of railroads.

It was all full steam ahead until 1884 when his father, George, was convicted of embezzling from the operating budget of the Enterprise Mill to fund his own speculation in the cotton market. Sentenced to six years but serving only two, the elder Jackson was a broken man, falling back on the bosom of the family for his subsequent support.

Perhaps, in part, because of this family scandal, James U. Jackson redoubled his efforts to make a name for himself and restore the family honor. Always a man of seemingly boundless energy, he threw himself into civic and commercial enterprises on behalf of his native city, such as organizing the 1888 Augusta National Exposition and spearheading the 1889 construction of the Bon Air Hotel. That same year, he married for the second time—his first wife, Minnie, died when she was only twenty-six, leaving one surviving child. He had four children with his second wife, Edith.

Jackson first made his mark in South Carolina in 1890 when he bought 5,600 acres on the Savannah River opposite downtown Augusta and established the North Augusta Land Company. He now had the acreage he desired, but he needed to develop it. Given his background in railroad investment, Jackson knew the value of linking his new property to commercial centers in the region. Thus, he negotiated the construction of a steel bridge between Augusta and his new town. This structure, later called the Thirteenth Street Bridge, was dedicated to Jackson's memory in 1939.

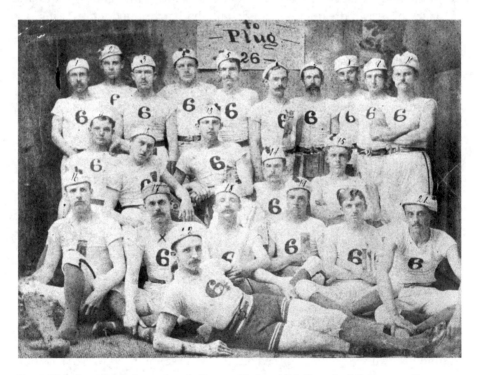

James U. Jackson on firehouse baseball team. He is seventh from the left, top row. *Reese Library, Augusta State University.*

1906: James U. Jackson Revisits the Dream of a Town on the River

An even more adventurous enterprise was his creating in 1897 a trolley line running twenty miles from the Bon Air Hotel in Augusta through North Augusta and eventually to Aiken. Christened the Augusta-Aiken Railway, it was perhaps the first interurban railway in the American South. Many skeptics told Jackson that such a system could not be built, but through the use of intermediate power stations—there was a key steam plant on the Clearwater Road—he was able to build a line that operated successfully for thirty years.

In 1902, his son, John William Jackson, built the now legendary Hampton Terrace Hotel, named for Confederate general and South Carolina governor Wade Hampton III. With three hundred guest rooms and a host of luxurious amenities, the hostelry made North Augusta a winter resort to rival Aiken.

The town of North Augusta was chartered in 1906, but three years earlier, James Jackson would begin an even more ambitious campaign that he periodically renewed for years thereafter. He argued for the creation of a new county, carved from parts of Aiken and Edgefield Counties, with North Augusta as its county seat. Jackson financed the land survey in this first attempt, which failed; but that did not stop him. He tried several more times to gain political support for his plan, proposing various names for the new county, including Heyward, after former Governor Duncan Heyward, and Edisto.

Although this particular scheme never gained sufficient support, Jackson was a tireless promoter of his new town. When President William Howard Taft visited the area in 1908, for example, Jackson personally accompanied him on a trip from Augusta to Aiken on his electric railway.

Yet, like Henry Shultz before him, Jackson's dream lost some of its luster over time. In 1916, just months after taking over full control of the Hampton Terrace Hotel, the huge complex was destroyed by fire. Not yet open for the winter season, the building was under

Statue of James U. Jackson by Maria Kirby Smith. *Tom Mack.*

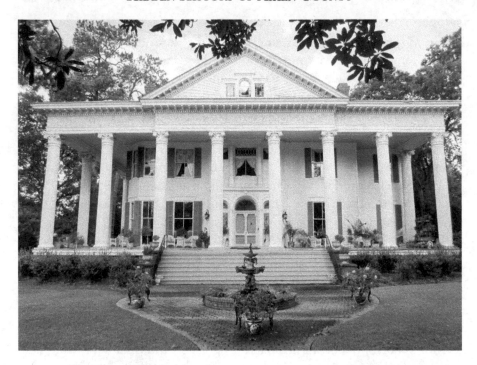

Rosemary Hall. *Tom Mack.*

renovation when a fire due to faulty wiring started in the west wing. Despite the efforts of multiple fire departments—four from Augusta—the place burned to the ground. Insufficient water pressure was listed as one cause for the total loss.

Jackson spent the next eight years of his life trying to put together a funding package to rebuild his luxury resort. He died in 1925 without achieving that goal.

Still, James U. Jackson, "dreamer and master builder," left behind a remarkable legacy. His twenty-two-room home Rosemary Hall still stands on Carolina Avenue; what is more, the town of North Augusta, whose residential and recreational reputation has been enhanced in recent years, stands as a testament to one remarkable man's vision and energy.

1910: AIKEN MANSION BOASTS TWO SIGNIFICANT LITERARY LINKS

It was in our little house in Aiken, in South Carolina, that he was with us most and we learned to know him best, and that he and I became dependent upon each other in many ways," wrote novelist Gouverneur Morris after the death of his friend Richard Harding Davis in 1916.

Davis, who was perhaps the most important journalist of his day as well as a fiction writer and playwright, spent several months during the winter of 1910–11 and again in 1912 at the home of Morris and his wife in Aiken. The rambling "cottage" still stands at the corner of Horry Street and Colleton Avenue; the property, enclosed by a high brick wall, takes up nearly half a block.

According to Morris's own reminiscence, both men, thanks principally to Davis's indefatigable "youthfulness of spirit," enjoyed conjuring up adventures together, imagining what it might be like to be a pirate or going so far as to make a list of what they might need for an elephant-hunting expedition in Africa—"guns and medicines and tinned things." Before Davis arrived, Morris avowed, "Our house had no name. Now it is called 'Let's Pretend.'"

On Davis's part, the fanciful musings may have served as a psychological safety valve because he was having a rough time of it in his everyday life—his mother had died some months before, and he was seeking a divorce from his first wife, Cecil Clark Davis, from whom he had been separated for some time.

The dissolution of his marriage could be blamed, in part, by his infatuation with husky-voiced vaudeville performer Bessie McCoy, whose claim to fame

Let's Pretend. *Tom Mack.*

up to that point in her career was her rendering of a song entitled "The Yama Yama Man" in the Broadway production *The Three Twins*. Her sexy rendition of this tune about a comical bogeyman garnered rave reviews—Ginger Rogers recreated the number in a 1939 film—and won the heart of the journalist-adventurer twice her age.

Despite his friend's troubles, Morris felt that Davis's visit in the last months of 1910 and the first months of 1911 ushered in "one of Aiken's very best winters."

"The spirea was in bloom, and the monthly roses; you could always find a sweet violet or two somewhere in the yard; here and there splotches of deep pink against gray cabin walls proved that precocious peach-trees were in bloom," wrote Morris. "It never rained. At night it was cold enough for fires. In the middle of the day it was hot. The wind never blew, and every morning we had a foursome for tennis and every afternoon we rode in the woods. And every night we sat in front of the fire and talked until the next morning."

Morris and Davis had a great deal to talk about since both shared public lives. Of the two, Davis was the more famous. Born in Philadelphia in 1864, Davis was destined to be a writer; his mother, Rebecca, was herself a

Richard Harding Davis.
Library of Congress.

celebrated author—her novella *Life in the Iron Mills*, first published in 1861, is considered a masterpiece of literary realism—and his father, a newspaper editor. He experimented with a number of literary forms when he was an undergraduate at Lehigh University—during my graduate school days at Lehigh, his name ranked high on the list of honored alumni.

Davis spent years on the staff of newspapers in Philadelphia and New York, but eventually, while still in his twenties, he became an editor at *Harper's Weekly*. Handsome and always fashionably dressed, Davis came to epitomize the Gay Nineties. He was much like the title character in his first collection of short stories, the dapper Courtlandt Van Bibber, an affluent and ebullient man about town. Davis was a social creature, enjoying the company of other fun-loving people—during his New York years, for example, he befriended the artist Charles Dana Gibson and the actress Ethel Barrymore—and he glowed with an essentially good-hearted self-confidence.

Of all of his fictional works, my favorite is *Gallegher* about an office boy at the *Philadelphia Press*, the newspaper that gave Davis his start. "Quick and cheerful," Gallegher has a nose for crime and a knowledge of the city's underbelly that puts the professional reporters to shame. During the course of this lively tale, he catches a murderer and helps his paper scoop its rivals on two of the biggest news stories of the day.

Of Davis's idealized characters, Morris himself commented, "Some critics maintain that the heroes and heroines of his books are impossibly pure and innocent young people. R.H.D. never called upon his characters for any trait of virtue or renunciation or self-mastery of which his own life could not furnish examples."

Long before Ernest Hemingway, Davis cultivated the persona of the reporter-adventurer, playing the lead role in a number of volumes devoted to his travels around the globe, including books on the American West, the Mediterranean and Latin America. He was also a risk-taking war correspondent, covering first-hand the Greco-Turkish War in 1897, the Spanish-American War in 1898, the Boer War in 1900, the Russo-Japanese War in 1904 and the first year of World War I.

After all of this exotic globetrotting, what did Davis think of Aiken? He called it "a sort of informal Newport," a more casual version of the Rhode Island coastal community that served as a summer resort for the rich and famous during the Gilded Age. In Aiken, he engaged in equestrian pursuits and fine-tuned his golf game under Morris's tutelage. He even tried his hand at flying. On assignment for *Collier's*, Davis boarded a Wright biplane, which had landed in a polo field, and experienced the then-unusual exhilaration of manmade flight. According to Davis, it was a "thrill that makes all other sensations stale and vapid."

So goes the story of Davis, but what about Davis's host in Aiken? Gouverneur Morris was the namesake of his great-grandfather, who was one of the authors of the United States Constitution. He wrote scores of popular novels and stories, including many that were made into films. His two most notable cinematic translations were *Penalty* (1920), which starred Lon Chaney as the deformed Blizzard, a San Francisco crime boss, and *The Man Who Played God* (1932), which starred George Arliss as an errant philanthropist. The latter production was to prove a break-through vehicle for Bette Davis, who, according to at least one source, was almost ready to give up any hope of a career in Hollywood and return to New York. The success of this film made her change her mind.

Gouverneur Morris.
Library of Congress.

Before his death in 1953, Gouverneur Morris—Davis generally called him "Guve" or Guvey"—had provided either the story or the screenplay for over twenty motion pictures. As a consequence, he made enough money to finance a winter home in Aiken. It was, however, his residence in Bedford Village, Connecticut, that served as a backdrop of the Davis-McCoy wedding in 1912. Morris was best man, and Ethel Barrymore was matron of honor. Theirs was a presumably happy union that produced one child, a daughter named Hope.

Morris proved to be a steadfast friend, even after Davis's death four years later from a heart attack at the age of fifty-two. Knowing that the widowed Bessie needed additional funds—she had returned to the stage to make ends meet—he arranged for the posthumous publication of Davis's letters.

Chapter 20

1912: AIKEN HAS TIES TO *Titanic* TRAGEDY

In one key scene in James Cameron's film epic *Titanic* (1997), the two principal fictional characters in the script are entering the first-class dining room when they encounter two historical figures that were part of the real-life maritime disaster. Rose Bukater, played by Kate Winslet, introduces Jack Dawson, played by Leonardo Dicaprio, to one of the richest men in America and his new bride. John Jacob Astor, portrayed by Eric Braedon, and Madeleine Astor, portrayed by Charlotte Chaton, play cameo parts in the movie, but on the passenger list of the doomed ocean liner, they were prominent figures.

Astor himself, the fourth generation of his family to bear the name John Jacob, had already been the subject of considerable notoriety when after his divorce from his first wife, the Philadelphia socialite Ava Willing, the forty-seven-year-old multi-millionaire suddenly decided to marry eighteen-year-old Madeleine Force. High society was in a state of shock because the Astor family, which held title to a considerable portion of Manhattan real estate, had long been a mainstay of the social register; Colonel Astor—his military title was derived from his involvement in the Spanish-American War—increased the family's valuable urban holdings, including investment in what was to become the Waldorf-Astoria Hotel.

It is theorized that the couple traveled to Europe and Egypt for their honeymoon, in part, to escape the press back home. Like many celebrities in our own time, the couple was hounded by the press before, during and after their nuptials. When news of the engagement became public, Madeleine was followed by reporters, and all of the attention eventually led to what

was described as a collapse due to "nervous and physical strain." Thus, she sought seclusion in her parents' Manhattan residence. With Madeleine temporarily out of the picture, the paparazzi turned their attention to her relatives; her father reportedly chased a photographer with his cane when the latter tried to take his photograph outside a jeweler's shop. Prior to the ceremony itself, to ensure their privacy, the couple leaked to the press their intention of getting married in a country hotel, but the knot was actually tied in the ballroom of the Astor mansion in Newport.

Madeleine Astor. *Library of Congress.*

While on their honeymoon, Madeleine conceived their one and only child, also to be christened John Jacob, and it was presumably her wish that they return to America because that is where she wanted to give birth. Their decision to book passage on the RMS *Titanic*—they boarded in Cherbourg, France—would seal their fate.

There are differing eyewitness accounts of Colonel Astor's final moments on the ship on April 14, 1912; it is certainly true that he calmly escorted his young wife to the boat deck, where he discovered that she had dressed in one of her lighter suits. He then ordered his valet Victor to bring a heavier dress from their suite, and when he returned, Astor and his wife's maid Rosalie helped her change on deck into warmer clothes. Astor next led Madeleine to one of the last lifeboats, informing at least one crew member that his wife was in a "delicate condition." Some survivors spoke of how he saluted those in the boat as it was lowered into the water. Madeleine herself reported afterward that he said to her, "The sea is calm, and you will be all right. You are in good hands, and I will meet you in the morning."

Madeleine Astor, her maid and her nurse Caroline survived; John Jacob Astor and his valet perished. Of the 1,517 people who lost their lives when the ship sank, the bodies of slightly over 300 were recovered, including that of John Jacob Astor. Because of the condition of his remains, there is now

some consensus among historians that he may have been crushed when one of the ship's funnels fell as the vessel sank into the sea. The personal effects recovered with his body included a gold watch, gold and diamond cuff links, a diamond ring, considerable paper currency ($2,240 and 225 pounds sterling) and various gold and silver coins.

At the Astor mansion on Fifth Avenue, Madeleine eventually gave birth to their son, whose legitimacy as a "true Astor" was questioned by certain members of the family, including his half-brother Vincent, John Jacob's son from his first marriage. It was Vincent who inherited the bulk of the family fortune when Madeline remarried—a provision in her husband's will gave her the proceeds from a considerable trust fund, reputedly as much as $5 million, as well as the Fifth Avenue mansion as long as she remained a widow.

After two years of relative seclusion following the *Titanic* tragedy, Madeleine—often called "the girl widow" in the press—reappeared on the social scene, hosting parties at both her seasonal residences, the summer home in Bar Harbor, Maine, and the winter home that she leased in Aiken at 325 Colleton Avenue.

She had always been an avid sportswoman. The daughter of a prominent Brooklyn family—her father, William, owned a shipping firm, and her mother's father had been mayor of the city—Madeleine was educated at

Astor House. *Tom Mack.*

the best private schools in New York and proficient in the pastimes of other debutantes her age, particularly equestrian activities, yachting and tennis.

In the latter regard, it was said that her socially ambitious mother steered her two daughters particularly toward tennis since she felt that they looked best in tennis togs. In August 1914, the *Washington Post* reported that Madeleine won the women's tennis tournament at Bar Harbor, Maine: "From the start [of the final match] Mrs. Astor had the better of it. She won six consecutive games in the first set without even letting her opponent get as close as deuce in any one."

Soon, however, individuals both inside and outside her circle began to notice the attention she lavished on a childhood friend, the banker and newspaper publisher W.K. Dick. As children in Brooklyn, they knew each other for ten years before the Force family moved to Manhattan in 1906.

I have found at least two society features published in 1916 in the *New York Times* that mention Madeleine Astor's activities in Aiken, including her success in a "paper chase"—this is a version of the outdoor game of hare and hounds wherein one person plays the hare, who must leave a trail of paper pieces for the rest of the players, who are designated as hounds.

The other event was a tournament held by "the winter colony of golfers," during which Madeleine Astor and W.K. Dick were a prizewinning twosome. Coincidentally, the person who presented them with a trophy was none other than Hope Iselin, the benefactress of what is now Hopelands Gardens.

Madeleine and William wed that same year in Bar Harbor, and they eventually had two sons, William Force Dick and John Henry Dick. The couple was divorced in 1933.

Madeleine was to take one more walk down the aisle when she married handsome Italian prizefighter and film actor Enzo Fiermonte in the same year of her divorce from Dick. Fiermonte, who had been the middleweight champion in his native country, had been hired to teach John Jacob V, who was only four years younger than his coach, to box. The marriage caused a temporary rift between mother and son.

Only with the birth of her first grandchild two years later did Madeleine and her son patch up their differences. She was reportedly a doting grandmother. However, her third marriage also failed; she and Fiermonte divorced in 1938. Two years later, she died of a heart ailment in Palm Beach, Florida, at the age of forty-seven.

As an interesting end note, Brooke Astor, the widow of Madeleine's stepson Vincent, became a major philanthropist after her husband's death. She herself died in 2007 at the age of 105, having donated in the last fifty years of her life over $200 million to various New York–based institutions.

1918: AIKEN RETAINS TANGIBLE LINKS TO PRESIDENTIAL LOVE TRIANGLE

Aiken was home to "the other woman" at the heart of one of our country's most notorious presidential love triangles, the illicit romance between Franklin Delano Roosevelt and Lucy Mercer Rutherfurd.

Their relationship began in 1914 after the twenty-three-year-old Lucy was hired to be Eleanor Roosevelt's social secretary. Her husband, Franklin, who was, at the time, assistant secretary of the navy, was smitten by the beautiful, younger woman, and their romance—the exact nature of their affair, whether it was physical or primarily emotional, has never been corroborated—blossomed until his wife's discovery of intimate letters from Lucy in Franklin's luggage upon his return from a trip to Europe in 1918. "The bottom dropped out of my particular world," Eleanor later said of that moment of discovery, "and I faced myself, my surroundings, my world, honestly for the first time."

The standard version of what happened next highlights the intervention of Franklin's mother, Sara, who convinced her daughter-in-law not to divorce her son if he promised not to see Lucy again and persuaded Franklin not to choose Lucy over his wife because she thought that a divorce and remarriage to a Catholic meant his political suicide.

Although he swore to break off any contact with Lucy Mercer, there is plenty of evidence that Franklin Roosevelt did not keep his word. As recently as 2005, in fact, letters from Franklin to Lucy were discovered by the latter's granddaughters; these particular missives date between 1926 and 1928. Their correspondence seems to have accelerated during the presidential

years—it is thought, in fact, that Lucy attended all four inaugurations by special invitation. In their letters, Lucy frequently sought Franklin's help and advice on a variety of matters, including getting medical attention for her husband at Walter Reed Medical Center and facilitating wartime assignments for her stepsons. For his part, Franklin kept Lucy abreast of his travels—there is some conjecture that he provided her with detailed accounts of his plans so that they could schedule assignations—and he sent annual birthday telegrams to Lucy's natural daughter Barbara, signing them "your godfather."

Face-to-face meetings also resumed after Franklin's pledge to break off ties. There is evidence that Lucy Rutherfurd visited the White House under the code name "Mrs. Johnson." Phone calls that she made to the White House under that pseudonym were always placed either from Augusta rather than from her winter home in Aiken or from New York City rather than from her primary residence in Allamuchy, New Jersey.

Of course, it has long been public knowledge that Lucy Rutherfurd was with Franklin at his home in Warm Springs, Georgia, when he suffered his fatal stroke in April 1945. Lucy had accompanied society portraitist Elizabeth Shoumatoff and photographer Nicholas Robbins to the Little White House; the latter two were intent on capturing a likeness of the president, one in paint and the other on film. Lucy was particularly eager for Shoumatoff to paint FDR; the artist had completed over the years several flattering portraits of members of the Rutherfurd family. That was not apparently going to be an easy task because according to Shoumatoff's own recollection of her first sight of the president during those last days, one thought entered her head: "How could I make a portrait of such a sick man?"

When he fell unconscious on the afternoon of his death, Roosevelt was going through official papers while Shoumatoff was working at her easel; Lucy, who was in the next room, rushed in when she heard the artist cry out and waved smelling salts under the president's nose. He did not revive, and a doctor was quickly summoned. Even before knowing Roosevelt's fate—they were to learn of his death after making a phone call from a hotel along the route—Lucy and her party were already in Shoumatoff's Cadillac headed back to Aiken. Shoumatoff, who got lost on the dark roads, commented later that Lucy was overwhelmed, torn between concern for Roosevelt's condition and her fear of exposure.

Arriving in Warm Springs from Washington, D.C., shortly after midnight on the day of FDR's death, Eleanor Roosevelt confronted two difficult challenges, arranging for her husband's funeral, only eighty-three days into his fourth

term, and coping with evidence of his broken promise. When she asked for details concerning the president's last moments from those present at the time of his death, she was told that he was being painted by a Russian artist, a friend of Lucy Rutherfurd, and that both women had been in residence for four days.

Lucy herself lived only three more years, all the while keeping a photograph of Roosevelt in her bedroom; she died of leukemia in 1948 and was buried next to her husband in the family plot in New Jersey.

Lucy Mercer's ties to Aiken date from 1920 when she married Winthrop Rutherfurd two years after the untimely death from appendicitis of his first wife, Alice Morton, daughter of Levi P. Morton, vice president under Benjamin Harrison. Rutherfurd, who spent most of the year on his eight-thousand-acre estate in New Jersey, had already been in the habit of wintering in Aiken. At first, he and Lucy rented homes found for them by local broker Eulalie Salley, but eventually they decided to build.

Rutherfurd commissioned New York–based architect Julian Peabody to design and construct a fourteen-bedroom, fourteen-bathroom house for him on Berrie Road next to the Palmetto Golf Club where he served for a time as chairman of the greens committee. Three stories high, made of brick laid out in a pattern called Flemish bond—alternating headers and stretchers—

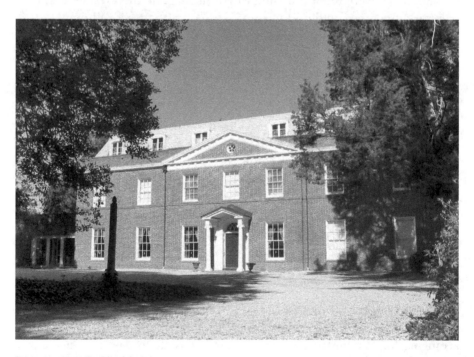

Ridgeley Hall II. *Tom Mack.*

and crowned by a mansard roof, the residence was christened Ridgeley Hall II, named after the first house on the property, built for previous owner Augustus Gardner; that house burned in 1926. Aiken must have appealed to Rutherfurd because of its many sporting activities; it is said that he was an avid rider, especially in regard to fox chasing and drag hunting.

As an interesting sidenote, Peabody, who is credited with the design of a number of winter residences in Aiken, came to a tragic end in one of the lesser known maritime disasters of the early twentieth century. He and his wife, socialite Celestine Hitchcock, the sister of prominent polo player Tommy Hitchcock, died in 1935 when the passenger liner *Mohawk* sank after colliding with a freighter off the coast of New Jersey. Hitchcock traveled from Aiken to New York to identify their bodies.

Winthrop Rutherfurd, known as "Winty" to his associates, came from an old New York City family whose fortune was based on extensive real estate holdings on the city's East Side. Rutherfurd's father had been a noted amateur astronomer; in fact, the Rutherfurd Crater on the moon is named after him. Winthrop graduated from Columbia University, but his family's wealth permitted him to abandon any attempt at a vocation and focus instead on other interests. He and his brother, for example, bred fox terriers, and one of their dogs, named Warren Remedy, won the Westminster Kennel Club's "best in show" for three years in a row: 1907, 1908 and 1909. The family's New Jersey estate Tranquility near Allamuchy encompassed five farms, and there they experimented with dog and cattle breeding.

Although it is said that he was, at one time, secretly engaged to Consuela Vanderbilt until her mother insisted that she break off the engagement in order to marry a British nobleman, the handsome but rather austere Winthrop Rutherfurd finally married for the first time at the age of forty. When his first wife, Alice, died after fifteen years of marriage, he looked to Lucy, thirty years his junior, to raise his surviving brood: four boys and one daughter. All evidence points to her having been a dutiful, attentive stepmother. She and Winthrop had one daughter of their own, Barbara, married to golfer Bobby Knowles.

The Rutherfurds are said to have been a very close-knit, private couple. Winty and Lucy did occasionally attend horse races, participate in amateur golf tournaments and support local charity events, but they tended to spend most of their time quietly at Ridgeley Hall.

The house passed out of the family's hands in 1944; for a time, it served as the convent of the Sisters of Charity of Our Lady of Mercy, an order which administered the Catholic schools in Aiken. Ridgeley Hall is now once again a private residence.

1932: "THE BLACK CARUSO" GETS HIS START AT PALMETTO PARK AND POND

Not much remains of what was once a major jazz venue in Aiken County—just some fragments of a concrete retaining wall and remnants of brick foundations. Yet the Palmetto Park and Pond on Carolina Springs Road in the Hamburg section of what is now North Augusta played host from 1932 to 1942 to some of the big names in modern American musical history: Cab Calloway, Louis Armstrong and Ella Fitzgerald.

By day, local African American residents visited the complex to enjoy the concrete swimming pool and sample the barbecue; by night, the two-story dance hall was the main attraction. The performance space became so popular that despite the enforced racial segregation of the time, the park started to advertise in area newspapers the availability of a "reserved dancing section for white people."

Thus, citizens of all races came to first learn about a new singing sensation eventually dubbed "the Black Caruso." That young man, a Hamburg native, was Arthur Lee Simpkins.

As a boy, he started singing in church—his parents, Alec and Emma Simpkins, moved the family across the river to Augusta where they joined the congregation of the Thankful Baptist Church on Walker Street. His only formal training occurred when he was an adult; after his marriage to Aurora Thomas, he took voice lessons from her sister, Ruby Robinson Jenkins, who was head of the music department at Paine College. For a time, Simpkins was a member of the Thankful Quartette, which recorded some of their gospel tunes in Atlanta. His name also appears as a soloist on the official program

of the funeral services held in October 1933 in memory of noted African American educator Lucy Craft Laney, founder of the Haines Normal and Industrial School.

Eventually, Simpkins's singing repertoire transitioned from gospel to other musical genres, and he began performing in more commercial venues while still keeping his day job as a porter at the George Railroad Bank. Most likely because of appearances he made at the Palmetto Park and Pond as well as the Lenox Theatre in Augusta, he was hired by the highly influential Earl Hines, whose Chicago-based orchestra made three-month summer tours, mostly through the American South. Hines, a jazz pianist and band leader, is credited with having launched the careers of Billy Eckstein and Charlie Parker, among others. He also introduced Simpkins to a national audience.

Since his career blossomed in a period of racial segregation, both in legalized and de facto forms, one has to look most often to the black media of the time for most of the press coverage related to Simpkins's professional life. By 1944, he was no longer with Earl Hines; instead, he toured the nightclub circuit, billed in the early part of his career as "The Black Caruso" and Arthur Lee "Georgia Boy" Simpkins but later on as "The Good Will Ambassador of Song." He sometimes worked as a headliner—both Liberace and comedian Joey Bishop once served as his opening acts—but most often he appeared as part of a variety program. From notices in the African American press, it is clear that he played some of the leading nightclubs in this country and abroad: the Latin Quarter in New York City, Swingland in Chicago, the Thunderbird in Las Vegas, Ciro's in Los Angeles, the London Palladium and even a four-week engagement at the Folies Bergere in Paris.

His career seems to have peaked in the early '50s when he made two notable recordings: *Let's Go to Beverly* and *The Magnificent Voice of Arthur Lee Simpkins*. The former was recorded on stage at the Beverly Hills Club outside of Cincinnati, Ohio. Both albums, produced under the Miranda label, offer a sense of how catholic Simpkins's musical choices were. He is said to have sung in six languages, and the selections on these two albums cover a wide range, mirroring his stage repertoire of "alternative jive and boogie-woogie tunes with arias from grand opera, lieder, and folk songs."

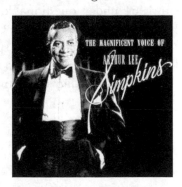

Arthur Lee Simpkins's album cover. *Collection of the author.*

Simpkins was also featured in films and television in the early '50s. An article in the *Los Angeles Times* in 1943 reported that he had signed a seven-year contract with MGM Studios. However, his first film role dates from ten years later when he appeared in the 1953 short entitled *Camp Jamboree*, which revolves around a group of entertainers putting on a show for the sailors at the naval base in San Diego; Simpkins sings two songs in the film. Another movie—this one a feature film entitled *Why Men Leave Home*, starring Richard Denning and Julie Bishop as a young couple trying to save a failing marriage—includes a cameo appearance by Simpkins.

He was also a presence on early television. The third and ninth episodes of *Cavalcade of Stars*, which premiered in 1951 with comedian Jackie Gleason as its first host, included performances by Simpkins. That same year, he also satisfied a viewer request on the popular program *You Asked for It* when a man from Pittsburgh, Pennsylvania, wrote in to seek information about an entertainer that he heard perform at the Florentine Gardens in Los Angeles. Simpkins, whose vocal range host Art Baker claimed ran from "C to F above high C," appeared on camera to sing "Marie." This particular appearance can be seen online on YouTube.

Throughout his career, Simpkins never lost touch with his church roots. He made frequent benefit performances at local churches, even after he moved permanently to the West Coast in the early '40s. Periodically, from 1943 to 1960, he sang at his adopted place of worship, the People's Independent Church of Christ in Los Angeles.

Mount Sinai Baptist Church in Los Angeles was the setting for another memorable church appearance; Simpkins performed at the memorial service for soul singer Sam Cooke, who was shot to death in Los Angeles in 1964 under questionable circumstances. Four years earlier, Simpkins had appeared on stage with Cook at a Shriners' benefit show, during which Sammy Davis Jr. received a special award.

There is no further media coverage that I could find after that date. The once-famous Arthur Lee Simpkins died in relative obscurity in Los Angeles in 1972.

Chapter 23
1933: Fred Astaire Makes Aiken His Winter Home

For two decades in the middle of the twentieth century, Aiken newspapers ran regular features on dancing star Fred Astaire. The coverage was particularly intense when he and his first wife, the former Phyllis Livingston Potter, made their annual winter visits to stay at the home of her aunt Maud Livingston Bull and her husband, Henry Worthington Bull.

The two couples made a convivial foursome. Astaire knew H.W. Bull, New York socialite and one-time president of the National Steeplechase and Hunt Association, even before he met his future wife; the two men had bonded because of their mutual interest in horse racing. Astaire's marriage to Bull's niece in 1933 brought the two men even closer together; that friendship, coupled with Phyllis's fondness for her aunt Maud, resulted in a mutual desire for shared experience. Thus, it became Fred Astaire's custom to spend the winter months with the Bulls at their home named Prickly Pear and to partake in the outdoor activities that made Aiken a major Southern sporting center.

Astaire was particularly fond of golf, and he spent many happy hours at the Palmetto Golf Club, founded in 1892. Local media captured a number of memorable moments on that course. In December 1937, for example, Astaire's golfing partner turned out to be actor Randolph Scott, who had driven, he said to reporters, 315 miles just to play a round with Astaire. Hundreds of local fans were said to have gathered in front of the Bull residence for a glimpse of both stars.

Scott, whose career was launched when Paramount signed him as the hero in a string of B westerns beginning in 1932, had worked with Astaire on

two of his classic musicals: *Roberta* in 1935 and *Follow the Fleet* in the following year. In both movies, Scott plays Astaire's sidekick. Scott's most recent film, a Jerome Kern-Oscar Hammerstein musical entitled *High Wide and Handsome,* was playing at a theater in Aiken during his visit; it starred Irene Dune and Dorothy Lamour, both vying for the affection of Scott's character, a farmer prospecting for oil in nineteenth-century Pennsylvania.

When Fred Astaire made his annual winter visit in 1938, the Aiken paper reported that area citizens turned the tables on the famous dance star. A group of local girls rang the doorbell of the Bull residence on Easy Street and asked if they could demonstrate the Big Apple, a swing dance named after the African American club of the same name in Columbia, South Carolina, where it first emerged before crossing over to the white community. According to one version of this encounter, Astaire came to the door with a peppermint jawbreaker in his mouth and stood mesmerized by the amateur performance.

Another Astaire visit to Aiken—this one in November 1940—was the subject of a spread in *Life* magazine, which included photographs of the

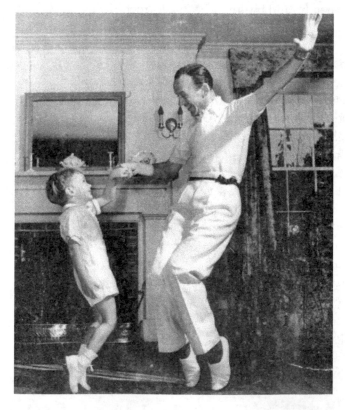

Fred Astaire and his son in Aiken. *Aiken County Historical Museum.*

star and his eleven-year-old son Freddy Jr. trying out some steps in one of the rooms of the Bull residence and Astaire himself leaping into the air, his arms and legs forming the letter "x" over the tenth hole at the Palmetto Golf Club. Astaire was, incidentally, judged to be an average golfer, one who never took the game too seriously; in fact, onlookers say that he often danced around the ball twice before hitting it.

Another photo accompanying the same article captures Astaire replicating in the aisle of the Patricia Theater, a now-defunct downtown Aiken movie palace, the dance moves projected on the screen in his latest film *Second Chorus*, in which Astaire and Burgess Meredith play two trumpet-playing friends vying for a spot in the Artie Shaw Orchestra.

Other sightings recorded in the local media include a February 1946 visit to a training track with Bull—Astaire himself did not ride for fear that an equestrian accident might damage his legs and feet; appearances at various events staged by the Aiken Preparatory School where Freddy Jr. was a student for two years, including a 1946 production of *A Connecticut Yankee in King Arthur's Court*, in which Freddy had a small part; and Phyllis's first-place finish in the mothers' dash during the school's Annual Sports Day in 1947.

Astaire's relationship to Aiken, however, did not survive his twenty-one-year marriage; his wife's death in 1954 closed the door on his wintering in the town. Still, "Aiken's favorite star," as the local media once proclaimed, made many happy memories for the local citizenry who found him invariably charming and approachable.

1936: ABDICATED KING FINDS SOLACE IN AIKEN

M y trouble is that I never really felt at home in England," confessed Edward, Duke of Windsor about his royal past. "When I first set foot on American soil as a very young man, it came to me like a flash: this is what I like. Here I'd like to stay."

Certainly, after his famous abdication speech in 1936—"I have found it impossible to carry the heavy burden of responsibility and to discharge my duties as king as I would wish to do without the help and support of the woman I love"—and his subsequent marriage to two-time divorcee Wallace Wakefield Simpson in 1937, the Duke spent a great deal of time in America, crossing and re-crossing the Atlantic to while away the remaining thirty-five years of his life at various watering holes of the rich and famous.

He and Wallace even spent some time in Aiken. They were guests of Edmund Pendleton Rogers and his wife, Dorothy Knox Goodyear Rogers, who married in 1931, a year after the latter's first husband, Frank Goodyear Jr., was killed while trying to pass a slower car in his Rolls Royce. According to several reports in the *Aiken Standard and Review* during the late fall and early winter of 1938–39, the Rogerses were happily anticipating the arrival of their glamorous guests, adding extra rooms to the main house on their ten-acre estate called Rye Patch and taking other precautions to ensure the privacy of the Windsors: covering windows that faced Whiskey Road and even making alterations to the seven-foot-tall brick garden walls. Those same articles—each one offering yet another estimate as to the travel plans of the duke and duchess—stressed Wallace Simpson's local connections.

Apparently, her great-great-grandfather John Montague once saved the life of George Washington; he is buried near Greenwood, South Carolina.

Rye Patch was a natural destination for the globetrotting Windsors since two of their closest American friends were Edmund's brother Herman Livingston Rogers and his wife, Katharine. Both of them had known Wallace long before she met the Prince of Wales. The son of railroad builder and sportsman Archibald Rogers, Herman, like his brother, was independently wealthy, and he decided at the age of thirty-five to retire from engineering— he had a graduate degree from the Massachusetts Institute of Technology— and devote himself to a life of travel and self-cultivation.

He and his wife set up housekeeping in Peking (now Beijing), China, Wallace enjoyed their hospitality in 1920; in fact, she lived with them for over a year. The threesome lost touch until seven years later when they reconnected on the French Riviera, where Herman and Katharine had relocated, buying a villa near Cannes. At this point, Wallace once again set up housekeeping with the Rogerses.

Theirs was a complicated relationship. Some observers went so far as to suggest that Wallace had always been attracted to Herman, who was very good-looking and suave; had it not been for the fact that she knew Katharine even longer than she did her husband, some think that Wallace may have acted on her desire. Whatever the dynamics of their friendship, here were three people closely connected.

In fact, the Rogerses were on the scene during the biggest crisis of Wallace's life: Edward VIII's ascension to the throne in 1936 and his subsequent abdication 326 days later. Most people are familiar with the story, but it bears repeating here. There was unwavering popular opposition against Edward's marriage to Wallace because she was a twice-divorced foreigner— she had been born and raised in Baltimore—whose two husbands were still alive. Since the monarch is also the head of the Church of England, which officially opposed such unions at the time, Edward's position was untenable.

Most reports indicate that Wallace herself understood that she could never be queen and that she was the one that urged Edward to propose to Stanley Baldwin, the Prime Minister at the time, that their marriage be morganatic. That is, Wallace would receive a lesser title, and their children, if they ever had any, would never inherit the crown.

Nothing, however, seemed to go their way, and while the king was negotiating the end of his reign back in England, Wallace sought shelter with the Rogerses in France. From their villa outside Cannes, Wallace made almost daily telephone calls to Edward. Herman Rogers played a

key part in the drama, acting as her informal press representative, issuing regular bulletins about her welfare to reporters parked outside the gates of their estate.

The couple also had a hand in facilitating the nuptials. Herman Rogers negotiated the use of a secluded chateau three hours outside of Paris as the site of the wedding and procured the minister; he even escorted the bride to the makeshift altar.

After the wedding, the Rogerses and the Windsors, now close neighbors, dined together several times a week and played golf and backgammon. These are also most likely the pastimes that they both enjoyed in Aiken. Wallace was not a horsewoman, but she did occasionally play a round of golf, and she very much enjoyed a game of cards. In fact, she is said to have been a very keen poker player.

American socialites greeted the Windsors with open arms—they generally considered his abdication as a very romantic gesture. For their part, the British were not so sanguine; most would agree with Edward's father, George V: "After I am dead, the boy will ruin himself in twelve months." They saw his act as a dereliction of duty.

Still, during his long retirement, the Duke of Windsor had plenty of time to act on his fascination with American culture, amusing his Aiken friends—the Rogerses, the Howes and the Armours—with his knowledge of their country. It is said that he enjoyed playing cards—although some fellow participants observed that he sometimes forgot the rules—and indulging in parlor games, particularly those in which he could amuse an audience of American friends with some of the facts that he had memorized over time, like the names of the presidents in sequence and all of the states and their capital cities.

Rye Patch, the principal setting of the Windsors' visit to Aiken, was given to the city after the death of Dorothy Knox Goodyear Rogers in 1982.

Chapter 25

1943–46: German P.O.W. Camp Bears Witness to Daring Escape and Brutal Murder

During World War II, twenty-one prisoner of war camps were established in South Carolina. One of those camps, initially a sub-camp of Camp Gordon in Augusta and then a sub-camp of Fort Jackson in Columbia, was built in Aiken County. Located on the present site of the Mattie Hall Health Center just north of the city of Aiken, the camp was a tent city surrounded by a barbed wire fence and monitored by strategically placed guard towers.

The first prisoners were around 250 German combatants in North Africa, and they were eventually joined by soldiers captured in Italy and France. By 1945, there were approximately 620 German prisoners in the camp, which was supervised by two officers and around forty enlisted men.

Some of the prisoners complained of the housing and the heat and forced labor—during the day, many of the inmates were assigned to supervised work details, such as doing contract labor in area farms, orchards, pulpwood operations and a fertilizer plant in Barnwell. On one such outing in January 1944 for the purpose of cutting wood on property southeast of town, one particular prisoner finally saw his best chance for an escape. Gerd Guztat simply walked away from the group, and his absence was not noticed until the guards called the prisoners for lunch. Guztat's escape, however, was not the result of a spur-of-the-moment decision; apparently, he had been carefully planning for just the right moment, having traced a map of Aiken on a piece of paper and stashed provisions, including two Hershey bars, in the woods.

When the alarm was raised, a county-wide manhunt ensued. Local roads were blocked, and a team of bloodhounds arrived from Columbia. Guztat,

however, managed to elude capture for forty-eight hours; it was finally due to a tip from an alert citizen that he was apprehended and his plan to hijack a plane and fly to Mexico was thwarted.

This act was not the last time that area residents heard of the unabashed Guztat. After his transfer to the presumably more secure Camp Gordon, the blond, blue-eyed German made another escape in April of the same year. This time, he and an accomplice stole a 1935 Ford belonging to a member of the military police. That car they abandoned in Augusta after it ran out of gas; thereupon, they stole a 1939 Chevy and made it all the way to Columbia, where Guztat was finally recaptured, asleep in a railroad freight car.

While one might admire the resolve and the derring-do of Gerd Guztat, there is nothing remotely admirable about the other headline made at Camp Aiken. This was the brutal murder of a twenty-three-year-old prisoner named Horst Guenther at the hands of his compatriots. On April 6, 1944, Gunther was found hanging from the crossbeam of a telephone pole in the camp. The authorities, at first, assumed that he had committed suicide, but emerging evidence soon pointed in a different direction.

Camp Aiken was probably haunted, not by supernatural entities but by a group of fanatical Nazis intent on purging from the imprisoned population

Horst Guenther. *U.S. Army Signal Center, Fort Gordon, Augusta, Georgia.*

anyone suspected of disloyalty to the Third Reich. These individuals were known as "holy ghosts" because, most often by cover of night, they visited their intended victims with the intention of frightening them into compliance with their military duty. Sometimes, however, it was determined that the only way that a particularly wayward soldier could salvage his honor was through death. In such cases, the targeted individual might be pressured to take his own life, perhaps in response to threats against his family back home, or the Nazis would take matters into their own hands. Both methods, incidentally, are dramatized in the play *Holy Ghost* by Jon Tuttle; set in the fictitious Camp Drayton in the South Carolina Lowcountry, the play was, in part, inspired by events that took place at Camp Aiken.

Thus, there is some evidence that Guenther may have been singled out by loyal Nazis because he spoke out in favor of America. One account affirms that he repeatedly sang the lyrics to "Deep in the Heart of Texas" to the infinite annoyance of some of his compatriots; other reports indicated that he liked jazz music, which was considered decadent by the Nazis because of its association with African Americans and Jews.

At the trial of his accused murderers, some of the defendants tried to mitigate the severity of their crime by claiming that because of his friendliness with the guards, Guenther was partially responsible for what they viewed as an unfair distribution of rations in the camp; others characterized Guenther as a stool pigeon, alerting the American guards to even the most minor infractions of camp rules.

Whatever the full story may be, six men were implicated in the attack on Guenther, and the two men most directly responsible for his strangling were themselves executed by hanging at Fort Leavenworth in Kansas in the summer of 1945.

Chapter 26

1951: AIKEN COUNTY REVIVES THE POLITICAL AMBITIONS OF STROM THURMOND

Born in Edgefield in 1902, James Strom Thurmond established a thriving law practice in Aiken in 1951 after his term as governor came to an end and he failed to win a seat in the United States Senate on his first try.

With his two partners, Dorcey Lybrand and Charles E. Simons—the latter became a federal judge in 1964—Thurmond prospered. The firm was especially successful in negotiating more money for landowners displaced by the construction of the 310-square-mile nuclear reservation, the Savannah River Site. For their services, they charged a fee equal to one third of the difference between the price that the government first offered and what they were able to negotiate.

Despite his busy schedule in court, Thurmond often took time in the middle of the day to swim or play tennis or go horseback riding with his new wife, the former Jean Crouch. Only four years earlier, in the Governor's Mansion in Columbia, the forty-four-year-old Thurmond married his twenty-one-year-old bride. They were attracted to Aiken as their future residence—they bought a comfortable brick house on Kalmia Hill—because it was halfway between his mother in Edgefield and her parents in Elko.

It was in Aiken that Thurmond decided to drop his first name James and to go by his middle name Strom. It was also during this time that the couple realized that they would have to adopt children if they ever wanted to enlarge their family.

In keeping with the prescribed gender roles of the time, Jean's sphere of influence was not to extend beyond the home. In a feature story printed in

1951: Aiken County Revives the Political Ambitions of Strom Thurmond

Strom Thurmond's first wedding. *Special Collections, Clemson University Libraries.*

January 1955 in the *Aiken Standard and Review*, for example, the writer praises the young wife for cooking all of the couple's meals and for doing most of the housekeeping—except for the weekly visits of a hired cleaning lady. In the article, Jean offers the reading public a glimpse of their domestic life, including the fact that when alone, they often ate breakfast foods at dinnertime: ham and eggs or sausage and grits.

According to most insider accounts, however, Jean Thurmond was more than just a "domestic engineer"; she was a very effective helpmate in the public arena as well. Her presence often tempered her husband's sometimes intemperate speech and improvident gestures. A notable exception to this pattern occurred while the couple was still in the Governor's Mansion and a crew from *Life* magazine arrived to do a three-page spread on Thurmond and his new bride and their physical regimen. In one particular photo, Jean stands at her bicycle, amused by her husband's successful attempt to balance on his head. In hindsight, this public evidence of his acrobatic skills did not

pay the political dividends that the couple may have envisioned at the time. Indeed, during the 1950 Senate race, Thurmond's victorious opponent, Olin D. Johnston, received widespread press coverage when he responded to one of Strom's campaign claims by remarking, "You know you get addled when you stand on your head."

Four years later, however, Thurmond's political fortunes improved considerably, and Aiken served as his base of operations as he became one of the few individuals to win a seat in the United States Senate as a write-in candidate. This time, Jean was also more successful at managing her husband's public persona. One of the few politicians' wives who got along with their husband's staffs, she often contributed astute advice on campaign strategy and, after the election, on public policy—indeed, she regularly attended official sessions of the Senate and its committees. In public settings, she would help Thurmond remember names, ostensibly jogging the memory of her husband, whom she affectionately called "Pappy"; and she often charmed reluctant supporters and grudging colleagues.

Her death after twelve years of marriage came as a tremendous shock. At first misdiagnosed with a nonmalignant brain tumor, Jean Thurmond suffered partial paralysis and endured two surgical procedures before her death following the second operation at the National Institutes of Health in Bethesda, Maryland, in 1960. She was only thirty-three.

At first, there was some uncertainty as to the choice of her final resting place, but Charles Simons is reputed to have said, "Well, Jean loved Aiken, and Aiken loved her." She was subsequently buried in Bethany Cemetery at the top of Laurens Street; her funeral service attracted political dignitaries from across the country, including a man who was soon to take up residence in the White House—Lyndon B. Johnson.

Interestingly enough, Strom Thurmond was to find his second wife in Aiken eight years later. In 1968, he married Aikenite Nancy Moore, whose father, Paul Moore, managed the F Area Separations Technology Division at the Savannah River Site. Thurmond was on hand on July 14, 1965, when the City of Aiken celebrated "Nancy Moore Day" in honor of the fact that the Aiken County "beauty with brains"—she was later to graduate with honors from the University of South Carolina in Columbia—had just won the Miss South Carolina pageant. Nancy was only twenty-two when she tied the knot with Thurmond, who was then sixty-six.

Within five years, she was to give birth to four children: J. Strom Junior, who was to have a career as a public prosecutor; Paul Reynolds, also a lawyer and member of the Charleston City Council; Juliana Gertrude, a

homemaker in Maryland, and Nancy Moore, killed by a drunk driver in Columbia in 1993. All of the children received their early education in Aiken. Excelling in a sport enjoyed by both of his parents, for example, Paul won a state tennis championship while still a student at Aiken High; before her untimely death, Nancy Moore was scheduled to follow in her mother's footsteps by representing Aiken County in the Miss South Carolina pageant.

Nancy Moore Thurmond had problems adjusting to her marriage and to the pressures of public life. She eventually admitted that she had become addicted to alcohol and prescription diet pills, but she successfully completed therapy for those problems. She also eventually decided that she could no longer live with her husband, and in 1991, they separated, physically but not necessarily emotionally. He lived in our nation's capital while she lived in Fox Chase along the border of Hitchcock Woods in Aiken, but they communicated almost daily by phone.

When Thurmond was admitted to a special assisted care section of the hospital in Edgefield in 2003, family members visited him daily; and when he died shortly thereafter, he left his estate to his wife and the three surviving children from his second marriage. Trust funds financed by the sale of real estate in Aiken and Union Counties were established for all three.

The only child not acknowledged in his will was his biracial daughter Essie Mae Williams, born out of wedlock in 1925 as the result of Thurmond's clandestine relationship with sixteen-year-old Carrie Butler, who worked for his family one day a week to help with the cooking. Carrie gave birth to their child in Aiken, but Essie Mae was sent away six months thereafter to live with Carrie's sister and her husband in Coatesville, Pennsylvania, where she grew up. Carrie herself stayed in Edgefield where she continued her contact with Thurmond until 1939; he eventually provided support for his daughter, both financial and emotional, but generally at a distance. He never admitted his paternity publically; that would be the task of the Thurmond family after he died. At the age of seventy-eight, Essie Mae finally gained public recognition of her status as Strom Thurmond's oldest daughter.

1952: Residents of Ellenton Become H-Bomb's First Victims

I t is hard to understand why our town must be destroyed to make a bomb that will destroy someone else's town that they love as much as ours. We love these dear hearts and gentle people who live in our home town," read a homemade sign posted on the outskirts of Ellenton in 1952. The sentiment expressed on this hand-painted message echoed the feelings of many of the residents of the town, particularly those who had lived most of their lives in Ellenton and whose family roots lay deep in the soil of nearby farms.

Many local citizens expressed pride in the fact that they were, in some way, contributing to the defense of the country—it was, after all, during the Cold War between the United States and the Soviet Union. Since World War II, Southern politicians had aggressively sought government military contracts as a way of rejuvenating the regional economy. Patriotism and economic boosterism frequently went hand in hand.

Still others, however, wondered why out of 114 possible sites for the projected facility built to refine nuclear materials for use in nuclear weapons, a 310-square-mile slice of Aiken, Barnwell and Allendale Counties came to be the final choice. Sacrifice in the defense of one's country was one thing; loss of one's ancestral home was another. "Angry and provoked" were terms that one Ellenton native, Lucius Sidney O'Berry, used to describe the feelings of some residents over what they came to perceive as the "seizure" of their property.

When out-of-town surveyors started showing up in 1950, many local residents predicted that some large-scale construction project was imminent, but most assumed that the site would incorporate unused property, perhaps

the pine barrens beyond the municipal limits. In her published reminiscence of this period in our local history, Louise Cassels wrote that "speculations flew over the community like migrant birds."

It was not until officials from the Atomic Energy Commission and representatives of the principal contractor, E I. du Pont de Nemours and Company, called a meeting in the local high school auditorium that Ellenton residents learned the full extent of the government's plans—the implementation of one of the largest construction projects in our country's history.

When the news spread beyond the local area, Ellenton and the neighboring towns of Dunbarton, Hawthorne, Leigh, Meyers Mill and Robbins became the object of considerable public curiosity. Newspaper headlines like "Town of Ellenton Dies, First Victim of H-Bomb" and "Displaced Persons of World War III" ignited the collective imagination. Louise Cassels writes of the arrival from all parts of the region of "sympathizers, sight-seers, newsmongers, and rubbernecks." To the residents of these small agricultural communities, the sudden interest of the outside world in their daily lives was both baffling and disconcerting.

In addition, as Cassels also notes, "the dread of appraisals hung over the people like an approaching [surgical] operation." Although the government promised property owners a fair price for their land, both had to agree on what constituted a reasonable offer. If both sides could not reach an agreement, condemnation proceedings were initiated. Eventually, according to some estimates, half the land acquired for what was to become the Savannah River Plant was acquired through condemnation.

Often disputes were settled in court, and in this regard, it is interesting to note that Strom Thurmond, then between political offices, frequently represented local landowners in these proceedings. Thurmond, who practiced law in Aiken during this time, may very well have enhanced his public reputation as an advocate of the "little man" in his struggle with "big government"—a position that held him in good stead when he decided to reenter the political arena and run for the U.S. Senate in 1954 as a write-in candidate.

All the while these disputes were making their way through the court system, construction on the nuclear facility continued apace, and residents of the affected area were evacuated. Louise Cassels writes about witnessing the removal of her neighbors; she herself remained in her home in Ellenton, one of the last residents to leave the town because her new home in Aiken was not ready for occupation. Soon residents became accustomed to seeing large houses moving down the road, perched on the beds of tractor trailers. Many families, at their own expense, decided to transport their residences to

nearby communities. Some displaced individuals left the county altogether, but most chose to relocate to Aiken, Beech Island, Jackson or the hastily constituted municipality christened New Ellenton. The town of Aiken, which boasted around seven thousand residents before the plant was built, more than tripled in size by 1953 because of a combination of displaced citizens and Savannah River Plant employees.

All in all, about eight thousand people were evacuated from the 275,000-acre site, including an estimated three thousand African American sharecroppers who received no compensation at all. In addition, approximately six thousand graves were excavated and the remains relocated.

Since 1973, Ellenton reunions have been held during which former residents sometimes revisit the site of their former town. Not much remains, except for some street curbing, fragments of building foundations and an artesian well, whose oval-shaped concrete encasement rises three

Artesian well, Ellenton, South Carolina. *Tom Mack.*

feet above the ground. Only in the mind's eye can Ellenton residents revisit the landmarks that once were the center of town life: enjoying a Saturday matinee at O'Berry's Movie Theater, socializing at local cafes like the Blue Goose and the Green Lantern, attending dance parties on the second floor of the dry goods store with its vintage Wurlitzer juke box in the middle of the room, swimming in Three Runs Creek, and catching up on the local news while doing a little shopping at the general store, referred to as "the long store" because of its shotgun shape. It measured 210 feet long with a gas station in the front, a bank in the back and a telephone company on the second floor.

Ironically enough, the sign referenced in the first paragraph of this chapter—hand-painted by twenty-year-old Ellenton resident Bonner Smith and temporarily attached to a road marker at the city limits—has been preserved; it is on permanent display in the Aiken County Historical Museum.

1989: JOYE TO JUILLIARD

A Grand Aiken Home Has a Second (and Third) Life

When he bought a modest inn in Aiken in 1896 and transformed it into a magnificent sixty-room mansion, William C. Whitney had one thought in mind, and it was not necessarily the acquisition of more property. He already had nine houses, three on fashionable Fifth Avenue in Manhattan. This tenth residence was to be a gift for his bride, Edith Sybil Randolph, whom he met in Aiken earlier that same year.

Made a widower by the death of his first wife, Flora Payne Whitney, the sister of Oliver Payne, who had been one of J.D. Rockefeller's partners in the creation of Standard Oil, Whitney was smitten by Flora. He was eager to build a sanctuary for the two of them, far from the machinations of his former brother-in-law, who was determined to have his revenge after he learned of W.C.'s plan to remarry and thus dishonor the memory of his sister.

Indeed, Whitney's second marriage was destined to be unhappy. Not only did Oliver Payne manage to win the loyalty of two of Whitney's four children from his first marriage—they agreed to snub their father in exchange for a promise to inherit the Payne millions—but Flora, the ardent equestrian, died from a fall only months after the house, christened Joye Cottage, was introduced to a glittering assembly of the rich and famous during a Christmas party in 1897.

After W.C. Whitney's death seven years later, the house became the property of his faithful son Harry and, in turn, Harry's daughter and W.C.'s granddaughter, Flora Whitney Miller, the last of the family to take an interest in the five-acre estate, which passed out of their hands in 1980.

For some time, the fate of Joye Cottage was uncertain. It can be said that it was spared the wrecking ball due to the happy intervention of two young men, Steven Naifeh and Gregory White Smith, who took it into their heads one rainy weekend in Manhattan, to walk from their four-room apartment to the showroom at Sotheby's to gaze longingly at the real estate listings.

There they read the following: "Gracious country estate...landscaped grounds lush with Southern vegetation, white columns, expansive 100-foot veranda facing formal garden and pool...sweeping lawns framed by towering oaks and pines...timeless appeal...the very legacy of understated classic design [Whitney is said to have consulted with famed architect Stanford White in drawing up the plans]...the essence of American aristocratic style."

They were hooked, and after a lengthy negotiation, with a number of surprising twists and turns, they finally bought the property at about a third of the asking price. The rest is history or, at the very least, a vastly entertaining saga of their renovation struggles, all admirably told in their book *On a Street Called Easy, In a Cottage Called Joye*.

In short, Naifeh and Smith, whose Pulitzer Prize–winning biography of artist Jackson Pollock was published shortly after their move to Aiken,

Joye Cottage. *Tom Mack.*

somehow brought life back to the twenty thousand square feet of living space. The imposing "cottage" became their home.

This, they thought, was the happy-ever-after ending of their story. They had acquired the home of their dreams and, three years earlier, had even cheated death. In 1986, Greg Smith was diagnosed with an inoperable brain tumor and given only three months to live. How the two coped with that diagnosis—and their quest to find a cure—is the subject of yet another engrossing autobiographical volume *Making Miracles Happen*. The book's title says it all; Naifeh and Smith somehow found a way to prove the doctors wrong, and Greg Smith miraculously bounced back.

Their heightened consciousness of their own mortality, however, made them contemplate the fate of the house that they had come to love, and they subsequently decided to deed the property to the Juilliard School in New York. "Music and art have given us such great joy—in both senses," Naifeh and Smith asserted. "By helping Juilliard in its mission to train musicians and artists and spread the joy to future generations, we can give back a thousand fold."

Furthermore, they eventually came to the decision to start building a bridge between the town and the school during their own lifetimes. Thus, since 2009, students, faculty and alumni of the Juilliard School have come to Aiken for a week every March to perform at various locations in the city and hold master classes in the local schools. Plans are now afoot to extend Juilliard residencies to other times of the year by bringing vocalists, instrumentalists, dancers and actors to Aiken as part of Juilliard's year-round presence in the city.

Thus, two remarkable Aiken residents brought new life into an old house, not only by their stunning restoration of the building and grounds but also by their creative adaptation of the indoor and outdoor space as a future retreat for generations of artists.

BIBLIOGRAPHY

Bass, Jack, and Marilyn W. Thompson. *Strom: The Complicated Personal and Political Life of Strom Thurmond*. New York: Public Affairs, 2005.

Bleser, Carol. *The Hammonds of Redcliffe*. New York: Oxford University Press, 1981.

————, ed. *Secret and Sacred: The Diaries of James Henry Hammond, a Southern Slaveholder*. New York: Oxford University Press, 1988.

Bonner, James C., and Lucien Roberts, eds. *Studies in Georgia History and Government*. Athens, GA: University of Georgia Press, 1940.

Browder, Tonya Algerine, and Richard David Brooke. *Memories of Home: Reminiscences of Ellenton*. Columbia, SC: South Carolina Institute of Archaeology and Anthropology, 1996.

Bryan, J. and Charles Murphy. *The Windsor Story*. New York: William Morrow & Company, 1979.

Byrnes, James. F. *All in One Lifetime*. New York: Harper and Brothers, 1958.

Carlton, David. *Mill and Town in South Carolina*. Baton Rouge: Louisiana State University Press, 1982.

Cassels, Louise. *The Unexpected Exodus: How the Cold War Displaced One Southern Town*. Columbia, SC: University of South Carolina Press, 2007. First published 1971.

Childs, Arney Robinson, ed. *The Private Journal of Henry William Ravenel, 1859–1887*. Columbia, SC: University of South Carolina Press, 1947.

Davis, Curtis Carroll. *That Ambitious Mr. Legare: The Life of James M. Legare of South Carolina*. Columbia, SC: University of South Carolina Press, 1971.

Derrick, Samuel. *Centennial History of the South Carolina Railroad*. Spartanburg, SC: The Reprint Company, 1975.

Duncan, David E. *Hernando de Soto: A Savage Quest*. New York: Crown, 1995.

Dyer, John P. *"Fightin' Joe" Wheeler*. Baton Rouge, LA: Louisiana State University, 1941.

Edgar, Walter, ed. *The South Carolina Encyclopedia*. Columbia, SC: University of South Carolina Press, 2006.

Epps, Edwin. *Literary South Carolina*. Spartanburg, SC: Hub City, 2004.

Faust, Drew Gilpin. *James Henry Hammond and the Old South: A Design for Mastery*. Baton Rouge, LA: Louisiana University Press, 1982.

Ford, A.P. *Life in the Confederate Army*. New York: Neale Publishing, 1905.

Hall, Jacquelyn. *Like a Family: Making of the Southern Cotton Mill World*. Chapel Hill: University of North Carolina Press, 1987.

Haygood, Tamara Miner. *Henry William Ravenel: South Carolina Scientist in the Civil War Era*. Tuscaloosa: University of Alabama Press, 1987.

Henderson, P.F. *A Short History of Aiken and Aiken County*. Columbia, SC: R.L. Bryan Company, 1951.

Hendrick, Carlanna Lindamood. "John Gary Evans: A Political Biography." Dissertation, University of South Carolina, 1966.

Jacobs, Robert D. "James M. Legare: Nearly Forgotten But Not Lost." *The Southern Literary Journal* 4:2 (Spring 1972): 122–27.

Langford, Gerald. *The Richard Harding Davis Years: A Biography of a Mother and Son*. New York: Holt, Rinehart and Winston, 1961.

Lubow, Arthur. *The Reporter Who Would Be King: A Biography of Richard Harding Davis*. New York: Charles Scribner's Sons, 1992.

Mack, Tom. *Circling the Savannah: Cultural Landmarks of the Central Savannah River Area*. Charleston, SC: The History Press, 2009.

Maness, Harold S. *Forgotten Outpost: Fort Moore and Savannah Town, 1685-1765*. Pickens, SC: BPB Publishers, 1986.

Martin, Ralph G. *The Woman He Loved*. New York: Simon and Shuster, 1974.

Martin, Samuel J. *"Kill-Cavalry," Sherman's Merchant of Terror: The Life of Union General Hugh Judson Kilpatrick*. London: Associated University Presses, 1996.

McCarthy, Cormac. *The Gardener's Son*. Hopewell, NJ: Ecco Press, 1996.

McDaniel, Jeanne M. *North Augusta: James U. Jackson's Dream*. Mount Pleasant, SC: Arcadia Publishing, 2005.

Meriwether, Robert L. *The Expansion of South Carolina*. Kingsport, TN: Southern Publishers, 1940.

Mitchell, Broadus. *William Gregg: Factory Master of the Old South*. 1928. New York: Octagon, 1966.

Morris, Michael P. *The Bringing of Wonder: Trade and the Indians of the Southeast, 1700–1783.* Westport, CT: Greenwood Press, 1999.

Naifeh, Steven, and Gregory White Smith. *On a Street Called Easy, in a Cottage Called Joye.* New York: Little, Brown, 1996.

O'Berry, Lucius. *Ellenton, SC: My Life…Its Death.* Columbia, SC: South Carolina Institute of Archaeology and Anthropology, 1999.

Palmer, J.A. *Aiken, SC as a Health and Pleasure Resort.* Charleston, SC: Walker, Evans and Cogswell, 1889.

Perico, Joseph E. *Franklin and Lucy.* New York: Random House, 2008.

Portraits of the Past: A Pictorial History of Aiken County, SC. Aiken, SC: *Aiken Standard*, 2002.

Sewall, Michael. "The Gonzales-Tillman Affair: The Public Conflict of a Politician and a Crusading Newspaper Editor." Master's thesis, University of South Carolina, 1967.

Smedley, Katherine. *Martha Schofield and the Re-Education of the South, 1839–1916.* Lewiston, NY: Edwin Mellen Press, 1987.

Snapp, J. Russell. *John Stuart and the Struggle for Empire on the Southern Frontier.* Baton Rouge: Louisiana State University Press, 1996.

Todd, Leonard. *Carolina Clay: The Life and Legend of the Slave Potter Dave.* New York: Norton, 2008.

Toole, Gaspar Loren. *Ninety Years in Aiken County: Memoirs of Aiken County and Its People.* Aiken, SC: 1955.

Tuttle, Jon. *Two South Carolina Plays.* Spartanburg, SC: Hub City Writers Project, 2009.

Vandervelde, Isabel. *Aiken County: The Only South Carolina County Founded During Reconstruction.* Spartanburg, SC: The Reprint Company, 1999.

Willis, Resa. *FDR and Lucy.* New York: Routledge, 2004.

Zuczek, Richard. *State of Rebellion: Reconstruction in South Carolina.* Columbia, SC: University of South Carolina Press, 1996.

ABOUT THE AUTHOR

Tom Mack joined the faculty of the University of South Carolina–Aiken in 1976. Since that time, he has established an enviable "record of teaching excellence as well as outstanding performance in research and public service" for which the USC Board of Trustees awarded him the prestigious Carolina Trustee Professorship in 2008. He currently holds the G.L. Toole Chair in English.

Over the years, Dr. Mack has written over one hundred articles and chapters about American literature and American cultural history. Furthermore, since 1990, he has contributed a weekly column in the *Aiken Standard* on a wide range of topics in the

Dr. Mack with statue of William Aiken on Newberry Street, Aiken. *Michael Budd.*

humanities. He is also the founding editor of the *Oswald Review* (*TOR*), the first international refereed journal of undergraduate research in the

discipline of English; all articles published in *TOR* are available in digitalized form on library databases hosted by EBSCO Publishing.

Tom Mack's other book titles include *Circling the Savannah: Cultural Landmarks of the Central Savannah River Area* (The History Press), *A Shared Voice: Paired Tales by Writers from Texas and the Carolinas*, co-edited with Andrew Geyer (Lamar University Press) and *The South Carolina Encyclopedia Guide to South Carolina Writers* (University of South Carolina Press).

Dr. Mack is currently chair of the board of governors of the South Carolina Academy of Authors, the organization responsible for managing the state's literary hall of fame.

9 781540 207296